Whistler's Mother's
COOK BOOK

· · · · · · · · · · · · · ·

MARGARET F. MACDONALD

D0830194

POMEGRANATE ARTBOOKS *San Francisco*

To my mother

Second edition published in 1995 by Pomegranate Artbooks
Box 6099, Rohnert Park, California 94927

Pomegranate Europe Ltd.
Fullbridge House, Fullbridge
Maldon, Essex CM9 7LE, England

ISBN 0-87654-108-2

Library of Congress Catalog Card Number 94-67328

Pomegranate Catalog No. A771

Designed by Peter Howells

Printed in Korea
00 99 98 97 96 95 6 5 4 3 2 1

SECOND EDITION

CONTENTS

· · · · · · · · · · · · ·

ACKNOWLEDGMENTS

· · · · · · · · · · · · ·

I would like to thank the University of Glasgow and the Library of Congress for giving me permission to consult and publish excerpts from the Whistler manuscripts in the Birnie Philip and Pennell collections, and the New York Public Library for permission to publish excerpts from Mrs. Whistler's diary I am particularly grateful to Martin Hopkinson of the Hunterian Art Gallery, Nigel Thorp of the Centre for Whistler Studies, Tim Hobbs of Special Collections in the Library at the University of Glasgow, and Jack Baldwin, formerly of Special Collections, for all their assistance. I am also grateful to my mother and to my sister-in-law, Betty Mac-Donald, for trying out recipes, to my family, Norman, Kathy, and Helen, for enthusiastically sampling my versions of Mrs. Whistler's recipes, and to Gail Duff for editing them.

MARGARET F. MACDONALD

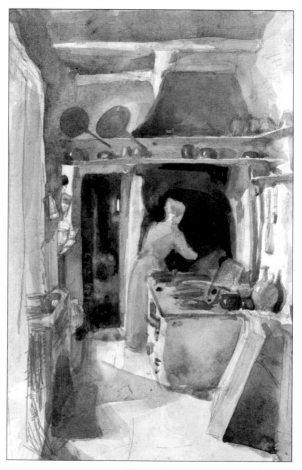

The Kitchen
Drawing, watercolor and pencil on paper, 30.4 x 19.7 cm (12 x 7¾ in.)
Freer Gallery of Art, Smithsonian Institution

THE WHISTLER
HOUSEHOLD
· · · · · · · · · · · ·

James McNeill Whistler was one of the most important American artists of the nineteenth century. His best-known painting is the beautiful portrait of his mother that hangs in the Louvre in Paris. The extensive collection of Whistler documents at the University of Glasgow includes letters written by Whistler's mother, Anna McNeill Whistler, which give a lively and intimate picture of the life of her family, and of her experiences during a long and extraordinarily varied life, in America, Russia, and Great Britain. There were also some books that had belonged to her, books of prayers and texts from the Bible, and a little manuscript book of recipes that she had kept for many years and that her son irreverently called her "Bible." The artist's father had been married twice, and the cook book, started by his first wife, Mary Roberdox Swift, was continued by Anna McNeill, who was his second wife.

Mary Roberdox Swift came from a military family. Her brother Joseph was superintendent of the military academy at West Point, and another brother, William, was a cadet there.

Mary was a lively and attractive girl, with dark, curly hair and big, expressive eyes. When she visited William at the academy, she was the "toast of West Point." On January 23, 1821, when she was not yet seventeen, she married one of William's closest friends, George Washington Whistler. Whistler was only twenty himself. Slim and good looking, he played the flute and was pleasant company. There was also a serious side to his nature, for he was deeply religious, and, having graduated at the same time as William, in 1819, he was to become a brilliant railway engineer.

The young couple faced some family opposition. They "were without adequate means of housekeeping," and George's pay was limited. He had to be away frequently on topographical duty. Regardless of opposition, they were married. Midshipman J. W. Swift gave his sister a little leather-bound notebook. "Mary R. Whistler" she wrote at the front—and again, half a dozen times, practicing her new married name. The book had a pretty leaf pattern around the cover and a square brass clasp. It was soon half filled, in her neat schoolgirl's handwriting, with basic recipes for everything from poached eggs to pumpkin pudding and peach marmalade. She learned how to run the household and to raise her young family. They had two boys, George William and Joseph Swift, and a daughter, Deborah. Six happy years of marriage ended with Mary's death in 1827.

George went to work as an engineer on the Baltimore and Ohio Railroad with another of his fellow cadets from West Point, William McNeill. William's sister, Anna McNeill, had been a very close friend of Mary Whistler. She was fond of the children and had come to care deeply for George Whistler.

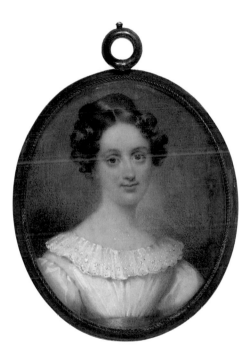

Unidentified artist (American, nineteenth century)
Mary Swift
© Hunterian Art Gallery, University of Glasgow

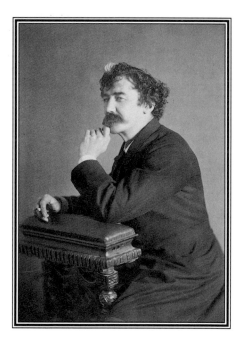

James McNeill Whistler

Photograph courtesy Glasgow University Library

They were married on November 3, 1831.

Anna Mathilda McNeill was born on September 27, 1804. She was only a month younger than George's first wife. Her father, Daniel McNeill, had been a physician in Edinburgh. After the death of his first wife, he emigrated to Wilmington, North Carolina. He soon established a successful practice, bought a small estate in the country, and remarried. His wife was "the beautiful Martha Kingsley." They had six children, four girls and two boys. Anna was their fifth child. The year before her marriage, she spent a year in Britain visiting relatives. She loved traveling, and the experience broadened her outlook. An attractive girl with a refined and charming manner, she appreciated beauty in nature and in art. She was kind, generous, and charitable, and, like George, she was devoutly religious.

When Anna and George married, they went to live in the country in New Jersey. Since it was obvious that George would prosper in civilian life, he resigned from the army in 1833 with the brevet rank of major. They moved to Lowell, Massachusetts, where he took up a post as chief engineer in the machine shop of a firm working on locks and canals, and he acted as consultant on the railroad from Lowell to Boston. Their first son, James Abbott Whistler, named after his father's sister, Sarah Abbott, was born in Lowell on July 11, 1834. It was only after his mother's death that James dropped the "Abbott" from his name and became known as James McNeill Whistler. He was a beautiful baby with dark, curly hair. His aunt Kate said later, "It was enough to make Sir Joshua Reynolds come out of his grave to paint Jamie asleep."

A second boy, William McNeill, was born two years later. There were now five children in the house. Over the next few

years Anna had to cope with a growing family upset by repeated moves. They hired an Irish girl, Mary Brennan, to help with the house and children. Then, in 1842, Major Whistler was invited to become chief engineer on the railroad to be built from St. Petersburg to Moscow. It was impossible to refuse such a flattering offer, and Major Whistler left for Russia that summer. Anna and the family could not follow until more than a year later. On the last stage of the journey to Russia, on the Baltic crossing, her youngest child became ill. There was no doctor, and he died in Anna's arms. It was a very sad reunion for George and Anna.

In spite of the inauspicious start, the Whistlers were very happy for the next six years in Russia. They first took a house on the "Galernaia" in a fashionable part of St. Petersburg. With a salary of $12,000 a year they could live very comfortably. Anna looked forward with some trepidation to directing a houseful of servants in a strange land. "I encountered fewer difficulties in house keeping than I had expected," she wrote. "I found every convenience in our kitchens, pantries &c—The servants speak some English, and my Mary such a comfort to me!"—for Mary Brennan had braved the journey to Russia rather than be parted from Mrs. Whistler and the children she had nursed.

The language barrier was always present. "Our cook who is uncommonly good natured, & speaks English, has to leave her duties whenever necessary to interpret for us." The servants seem to have appreciated their new mistress and tried to please her. On Easter Sunday,

> …there was the cooks ornamented loaf stuck full of flowers upon the breakfast table—& a small plate of colored eggs from each servant Dvanic, Porter & even Mr.

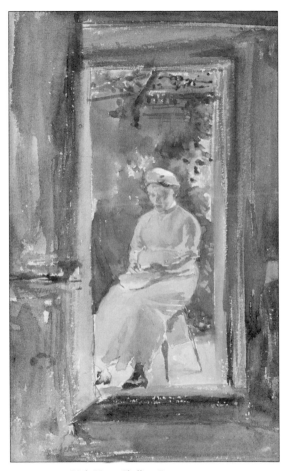

Pink Note: Shelling Peas, early 1880s
Painting, watercolor on paper, 24.3 x 14.6 cm (9⁹⁄₁₆ x 5¾ in.)
Freer Gallery of Art, Smithsonian Institution

Maxwells man Le Rong had sent up his, with the motto "Christ has risen" upon some. Alexander had selected the choicest he could buy made of wax or sugar for each of us, so that we felt obliged to present him with 5 silver rubles to repay him...

The Whistlers formed part of a close American circle, which included, of course, the American ambassador, Whistler's fellow engineers, and other professional men associated with the railroad, with their families. They upheld American traditions in religion, conduct—and food! For their first Christmas in Russia, they invited four American friends to join them to eat roast turkey and pumpkin pie. On another Christmas day,

> Mr Ingersoll and Wm. Winans dined with father and I, we had a Baltimore ham to relish turkey, and <u>pea nuts</u> for dessert, but mince pies or plum pudding I have not ventured to propose since the cholera season...

The children had their Christmas party separately:

> I had about sixteen to make tea for...Cook had made some of her most transparent jelly in lieu of fruit which one does not offer in these Cholera times, & if English palates did not fancy Pea-nuts the American lads were not slow to help themselves, & Stuarts sugar plums & candy went around.

Within this English-speaking circle she found opportunities to help those in need, to visit the sick and tend the dying, to feed and nurse people if necessary in her own house. Major Whistler was often away, and she worried, with some justification, about how he was looked after. They took a house in the

country for the summer, and she wrote from there in July.

> My dear Whistler left us last Thursday after a very early breakfast for Moscow I had put him up a nice prog-canister as he expected to be absent a fortnight & gave him a Yankee plum cake—which is thought so excellent in this land of few cakes—to take with my compliments to Col. Milnikoff.

That summer they had one particularly interesting visitor, the Scottish painter Sir William Allan, who was painting a series of historical works for the czar. Young Jemie was delighted to see him. His proud mother showed Sir William the boy's sketchbook—sketches of the family, biblical scenes, and great historical compositions crowded together—and Sir William was kind and thought they showed "uncommon genius." They all enjoyed

> …our excellent home made bread & fresh butter, & above all the refreshment of a good cup of tea! when he offered the cake basket afterwards to Sir William he rec-ommended the plum cake as being made at home & so like a Scotch bun!

The English-speaking cook was a gem. Without her Mrs. Whistler could never have entertained as lavishly as she did. In the country, with the benefits of dairy produce and fresh eggs from the farm, they fared even better than in St. Petersburg.

> Our cook had excellent hot rolls, minced meat, fresh eggs & coffee on our table by eight oclock, we were all blessed with health, to appreciate her skill appetites were ready & we had a jovial meal.

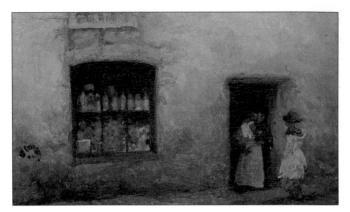

An Orange Note: Sweet Shop, 1884
Painting, oil on wood panel, 12.2 x 21.5 cm (4¹³⁄₁₆ x 8½ in.)
Freer Gallery of Art, Smithsonian Institution

Housekeeping was expensive, particularly when Mrs. Whistler was trying to maintain an American home and feed her family on good home cooking in a foreign land. Food from the States was precious. In 1847 she wrote to Jemie, who was in England:

> You know perhaps that brother George had a box of <u>Yankee notions</u> shipped for us last summer, the vessel was lost, but the cargo landed at some Russian port, & last week our boxes came at last <u>up our stair</u>. <u>Stuarts Candy</u> had nearly all been <u>tasted</u> away at the Custom House, but the cases of oysters hermetically sealed outwitted the Tekelivecks they managed to stick a knife thro the tin to detect Valenciennes (if smuggled in tin boxes ever) but the oysters are in perfect condition, & so I am well pleased to

find are jars of sweet-meats, for it is a pleasure to distrib-
ute among my friends the fine fruits of our native land.
Our Indian meal was wet & consequently spoilt, but no
matter father could not have ate it & the hominy satisfies
Willie, they only devoured one keg of biscuits & the
other is enough for our diminished family. The tea &
sugar I am very glad of. All these came directed to the
Embassy or we could not have imported them.

As well as all these imported necessities, she made full use
of the local produce. In the same letter, she went on to men-
tion delicacies that she had sent to Deborah:

Tell Mary she must have a line stretched across one of
the garret rooms & tie the Tongues in pairs to hang over
the cord. How many pairs were there sent? I intended a
doz pair of each kind, Reindeer & Neats. I have Mr
Merriellees bill for them.

The local meat and fish were good. In the hot summer of
1844, her guests were enjoying fresh salmon with green peas
and delicious drinks of iced mead. Their landlord "sent me in a
present of a plate of nectarines and Peaches, from his green
house, very acceptable, & at the rate they sell here, very valu-
able, I should probably pay a paper rouble a piece, these with
melons, & as fine cherries as I ever saw make our dessert fine!"
On the boys' birthdays there were "strawberry treats" for all
the neighborhood children, and Mrs. Whistler bargained hap-
pily and successfully with the fruiterers.

There were troubles as well as treats in the years in Russia.
A little son, John, was born in August 1845 and died a year
later. The older boys went to boarding school in the city, feel-

ing the separation as deeply as their mother. Then Jemie became seriously ill with rheumatic fever. He recovered, and they spent a summer in England, in a kinder climate. They attended the wedding of Deborah to the surgeon Seymour Haden. He was also an amateur etcher and encouraged Jemie in his enthusiasm for art. Jemie was ill again, and they decided he could not face another winter in Russia. He was sent to school in England and spent his holidays with the Hadens at Sloane Street in London. Only Willie was left at home. Then came the greatest blow of all: on April 7, 1849, Major Whistler died.

By the end of July Mrs. Whistler had returned to America with the two boys, James and Willie. She was in mourning—indeed, she wore mourning for the rest of her life—but her Russian friends, and the family to whom she was returning in America, helped her to reorganize her life in these new and straitened circumstances. Now that her husband was dead, she was to devote her life to looking after the children, completing their education, and keeping a home for them. In America they went first to Stonington and then took part of a farm-house in Pomfret, Connecticut, so that the boys could attend Christ's Church Hall School there. For the first year in Pomfret she kept a diary, which is now in the New York Public Library. It is very revealing in the picture it gives of the little family: the mother, strict with her boys even while she made every excuse for them; Willie, helpful and docile; Jemie, charming and rebellious. Willie thought he might become a minister. Jemie had asserted for years he aimed to become an artist. Needless to say, he was discouraged even while his talent was admired. He was urged to do something more useful, such

as engineering, like his father. No wonder he was rebellious! Anna recorded all the events of everyday life:

29 May. James has mortified me by playing marbles with the smallest boys instead of coming home regularly to meals, he never breakfasts with us!

22 June. Jemie not well today came back from school suffering head ache I administered an emetic & he was hungry for his gruel & cracker at tea time!—

There was another member of the household, Mary Brennan, who had become Anna's constant companion. She had been a farmer's daughter in the north of Ireland and was "very careful." Local girls helped with the washing and the cleaning, but Mary and Mrs. Whistler did most of the household chores themselves. In the kitchen every tedious task had to be done by hand: pounding almonds in a mortar, grating a coconut, chopping suet, stoning and preparing dried fruit, mixing puddings and cakes. Diet Bread (a light sponge cake) had to be beaten for about half an hour!

In Mrs. Whistler's recipe book instructions like "put it over a slow fire" or "bake in a quick oven" indicate the difficulty of being precise with coal- or charcoal-fired ovens that could not be thermostatically controlled. The arduous task of preparing the ingredients and the variability of the oven meant that recipes had to be simple and reliable. Care and patience were necessary. As a bride the first Mrs. Whistler had written down instructions for simple fare like bread-and-butter pudding in what seems like unnecessary detail. Anna was obviously a more experienced cook. She jotted down the ingredients for an impressive variety of puddings and cakes but rarely bothered to

remind herself how to go about them. In her diary she often mentioned what she had been cooking:

> 26 February. We all arose before the sun this bright & mild day…I felt the benefit of a long day—walked after having made plenty of apple pies…
> 23 March. I arose at 6 oclock…I assisted in the kitchen at the baking cakes to send to Debo—but felt by afternoon nearly worn out.
> 13 May. I went at sunset a walk with my dear boys & called to take Mrs Park guava jelly for Mary who is ill with Mumps.
> 22 June…. made a canister of cake…
> 30 July. Weather exceedingly close—I had to be in the kitchen—making currant jelly until late in the afternoon.

Pomfret was a good choice as a home. They entered quickly into the life of the community. Church and school proved satisfactory and living economical. Fruit could be obtained locally and cheaply. In the autumn she could make quince marmalade and apple jelly, and in October she was preserving peaches. She could get squashes, cucumbers, and pumpkins in season. It was absolutely necessary to stock the larder with sufficient pickled nuts and vegetables and preserved fruit to see them through the winter and add variety to their diet. They had a small garden where Mrs. Whistler enjoyed tending flowers, but it provided only a few of their basic needs. For a dollar a day, an old man who had served the major came occasionally to keep the garden in order. In May he was planting corn, but it was too cold to plant anything else. They were able to keep chickens and a pig. These were

Willie's province. Through 1850 she recorded their progress:

4 February. Willie had half agreed to sell his pig to Mr. Richmond last Sat. but repented his bargain & it was restored!

6 February. Willie was able to attend his pig & poultry in the morning. A hen had died in the night from its food freezing in its crop!

8 April. Willie moved his hen & chickens to the yard…

22 April. Today our dear Willie was up early to superintend the killing of the poor pig.

24 April. My dear mother attended to making the pigs head cheese, Nancy salted the hams & Mr. Fitts salted the pork

3 June. I went with Willie & paid C Mathewson for the pig $3 today.

Even this small attempt at self-sufficiency was extremely useful. All her recipes for cakes and puddings used a large proportion of eggs, as they did of milk and butter. Since she did not have a cow, dairy produce bulked large among her bills. Five pounds of butter in one week! It was particularly difficult to buy milk and butter in the winter. Her winter's supply of "most excellent butter" was bought in October. Milk she bought from a neighbor. In the first quarter it came to $12. From the same source she bought spareribs and sweet potatoes for 84 cents.

Many essential groceries could not be obtained locally. She paid 12½ cents a pound for cocoa shells. In February she was buying hominy and oranges; in March, a tin case of crackers; and at the beginning of December, Christmas cakes and candy,

sugar, and molasses. She bought coconuts as well as oranges and lemons. Nothing was wasted. The peel was used freshly grated, dried, and powdered, or sugared and preserved, to add fine flavor and texture to many puddings and cakes. She could not obtain many spices: ginger, allspice, cloves, whole nutmegs, and stick cinnamon were used liberally. The fragrance of freshly grated nutmeg compensated for the difficulties of grating it by hand.

By April her grocer's bill had grown to $69.49, and her stepson George, keeping an eye on her growing expenses, urged her to settle it. She could not afford to until the end of May. She decided, with her means becoming ever more limited, to practice further economies. Yet she continued to entertain friends and relatives. She loved children. Her strictness awed the older children, but the young ones adored her. "Donie gives me no trouble," she said when her young nephew came to stay, "tho his demands for peaches, crackers & milk are hourly. I intend to fatten him!"

Her income of $1500 a year had shrunk to $900, and the boys still had to complete their education. In July 1851 James, attempting to follow in the family tradition, entered West Point. After home cooking, the fare offered to the cadets did not suit him at all, and he supplemented it from his allowance and with parcels from home. His mother went to visit him in October:

> Of course I went laden with proofs of his having had his share of my time—the new set of shirts, collars hosiery…with a basket of home made cake & some fruit to fill up chinks, he was so grateful for!

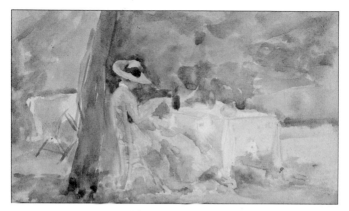

Breakfast in the Garden, 1880s
Painting, watercolor on paper, 12.7 x 21.9 cm (5 x 8⅝ in)
Freer Gallery of Art, Smithsonian Institution

The cake was made by Mary Brennan, who missed James as much as did his mother. "She is flattered by your relishing her cake," wrote Mrs. Whistler when she got home, "& wishes she could send you one every week." Next, Mrs. Whistler was sending him chocolates, "a bon bouche for you on <u>guard</u>." And perhaps feeling that Whistler had need of all the sympathy he could get, she sent some peaches to his professor at West Point. Whistler did not get home for Christmas—indeed, as the list of his demerits lengthened, he rarely qualified for leave at all. In the bitter December weather, with six degrees of frost, his mother wrote:

> I succeeded yesterday in making 3 doz mince patties—& a fine supply of ginger snaps. I hope you may get them for N Year—How many thoughts of my cadet lightened my toil in the cold kitchen!

The "Beefsteak Club"
© Hunterian Art Gallery, University of Glasgow
Birnie Philip Bequest

With James away at West Point, Mrs. Whistler decided to move house again. She took a cottage at Scarsdale on land owned by one of her closest friends, Margaret Hill, so that Willie could stay at home when he started to attend Columbia College and continue to enjoy his dinners of "beefsteak, hot coffee & muffin."

Whistler was discharged from West Point in June 1854. He was top of the class in drawing but failed his examination in chemistry. Whistler said: "Had silicon been a gas, I would have been a major-general." The family tried in vain to find him a suitable job. For four months he worked in Washington with the U.S. Coast Survey and acquired a useful knowledge of etching techniques. He earned $1.50 a day and doubtless appreciated the comprehensive parcels his mother continued to send him: shirts darned and shoes mended, sheets and towels, "3 loaves of bread & some ginger snaps!" In February he worked 5¾ days. In spite of anything his mother could say, as soon as he turned twenty-one and inherited the small amount of money left him by his father, Whistler resigned from the Coast Survey and left America for the last time, intent on studying art in France.

Willie was also proving difficult. He had to withdraw from Columbia, attended Trinity College for a while, and eventually went to study medicine in Philadelphia. His mother went with him, to keep house. During vacations he came home to the cottage. He was more obedient than James, but he still had habits that she deplored. She forbade tobacco, "so I have to cater fresh eggs & creamy milk & late breakfast to reconcile him to my embargo on its fumes." In December 1856 she wrote to Whistler in Paris to describe her preparations for Christmas:

…an active routine is mine every morning, that by frugality I may provide for hospitality & maintain the respectable caste, bequeathed me…And now I am arranging my claims to devote myself to Willie during his holidays,…I have succeeded in some apple & mince pies today, as part of my economy for frugal meat dinners, not to feast upon yet not to fast upon. Mrs. Popham generously supplies the Cottage with apples, that would decay if uncooked, tho some of the finest I select & take especial care of for Willie's enjoyment, these are secondary, only proofs of affections fore thought.

No wonder there are so many recipes for apple jelly and puddings and pies in Mrs. Whistler's cook book! Apples were always cheap and plentiful, though not always free. Putting minced meat as well as apples and dried fruit in her mince pies at Christmas was a practice going back to medieval times. The mincemeat we know today came into general use in Victorian times.

After Christmas Mrs. Whistler wrote to James again to describe life at the cottage:

Mary's always neat kitchen is as convenient to breakfast & dine in because of the china Closet connecting it with our Salle à manger, she gives us the best of buckwheats hot & hot from the griddle! ah if you could only join us in praising them & the excellent WChester butter, of which I had a firkin put down in one of the nicest quaker dairies.

In 1855 Mrs. Whistler had been virtually bankrupted by the failure of some stocks. She could still afford to have help

in the house until she moved with Willie to Philadelphia. Then, for the first time in nearly twenty years, they were parted from Mary Brennan. Mrs. Whistler had to be more economical than ever.

It was now three years since she had seen James. He was enjoying life in the Latin Quarter as much as possible on his modest allowance. In 1858 he set off on a tour of the Rhineland with a young artist friend, etching the people and scenery as he went. They ran out of money and Whistler wrote off for help. When none materialized they set off for home on foot. Whistler described their predicament to his sister:

> …the first night I made a portrait in pencil…for a plate of soup for Erneste and myself…I, for a glass of milk had to make the portrait of one of my young tormenters— the ugly son of the woman…for another portrait we had a piece of black bread and an egg…we came upon a Dorp where there was a fair…I there made portraits of "butchers and bakers and candlestick makers" for five groschen a piece that is a little more than fourpense!!

They eventually arrived at Aix-la-Chapelle, where the consul helped them out. They returned to Paris none the worse for the trip. Everyone was greatly impressed by Whistler's etchings. His brother-in-law, Haden, encouraged him to print and publish them as a set, the "French Set." But no one was more proud than his mother. She began to think that James might after all manage to make a living.

Anna herself was not as capable as she had been. In 1858 she was fifty-four and was particularly worried by eye trouble. But she was as active as ever. For the sake of her health she

visited the Sulphur Springs at Richfield and the Spa at Sharon Springs. She went to stay with friends and relatives all over the States. She had visited Deborah in London in 1852 when her second child was born, and she went again in 1860, for a full year. Even the Civil War did not stop her traveling to and fro.

In 1860 Willie married Florida King, the daughter of a cousin in Georgia. The family had strong Southern sympathies, and Willie joined the Confederate army as a surgeon. He spent much of the war in Richmond. His mother ran the blockade to visit him and was there to nurse his young wife when she fell ill and died in March 1863. There was no question of her remaining long to comfort Willie. She decided to run the blockade again in order to join James in London.

She arrived safely, only to find herself in the middle of a family row. Seymour Haden had objected to Whistler's bringing his beautiful red-haired mistress, Jo Hiffernan, to a family party. In fact, he objected to many irregularities in Whistler's life and friends. Whistler was sorry to upset his sister Deborah but was no longer able to stomach his brother-in-law's pomposity. Then his mother arrived, and there could be no question of Jo's continuing in his house at 7 Lindsey Row in Chelsea. Haden's attitude was one thing; his mother's opinion, quite another. Whistler had a frantic week finding alternative accommodation for Jo and for the French artist Legros, who had been staying with him, before traveling down to meet his mother at Portsmouth.

Poor Jo! When Whistler's mother was away she could stay with him, but his mother entirely disapproved of their relationship. When he sold a picture, she suggested he use the proceeds "to promote a return to virtue in her." Whether

Whistler followed her advice or not, within a couple of years he and Jo had parted, apparently amicably. Jo even looked after Whistler's son, Charles, who was himself an "infidelity to Jo." Mrs. Whistler does not seem to have known about him.

Meanwhile, Willie had also arrived in London. In February 1865 he was carrying dispatches through the lines to New York, and from there he sailed to Liverpool. When peace was declared, in April, he decided never to return. He was not qualified to practice medicine in England right away, but he set up house and specialized in throat and lung diseases, in which he became a recognized expert. In 1870 he married again. His wife was Helen Ionides, "Nelly," who came from a rich Greek family. They had been among James's earliest patrons.

James was making an attempt if not to reform, at least to conform, to his mother's way of life. On Sundays he escorted her along the riverside to Christ's Church. Occasionally her strictness embarrassed him. One day he invited two friends—potential customers—to dinner the following Sunday. She objected strongly, and he had to write hurriedly and apologetically, asking them to come on Monday instead. "You see," he said, "that my Mother exerts her influence over me, and Sundays are 'difficile'—" Except on Sundays, Mrs. Whistler was happy to welcome Whistler's friends into her new home. D. G. Rossetti lived only a few doors away in Lindsey Row. He and his brother William, and the poet Swinburne, were frequent visitors. Swinburne got on amazingly well with Mrs. Whistler and was nursed by her once when he was ill. But her first care was for James himself:

While his genius soars upon the wings of ambition the every day realities are being regulated by his mother, for

with all the high hopes he is ever buoyed up by, as yet his income is very precarious. I am thankful to observe I can & do influence him. The artistic circle in which he is only too popular, is visionary & unreal tho so fascinating. God answered my prayers for his welfare, by leading me here all those most interested in him remark the improvement in his home & health the dear fellow studies as far as he can my comfort, as I do all his interests _practically_ it is so much better for him _generally_ to spend his evenings tete à tete with me tho I do not interfere with hospitality in a rational way, but I do all I can to render his home as his fathers was

The house on Lindsey Row was sparsely furnished compared with the heavily ornamented rooms of overstuffed furniture then popular. This simplicity was dictated only partly by necessity. The rooms were distempered in shades of white and yellow and decorated with a few carefully placed fans and the Oriental china that he had begun to collect avidly.

Du Maurier described a dinner party given by Whistler in October 1863 during which the meal was served on these precious plates:

I dined with Jimmy and Legros; Poynter & Willie O'Connor were there…Jimmy doesn't seem to be doing much. He has bought some very fine china; has about sixty pounds worth, and his anxiety about it during dinner was great fun.

At one of his dinners there were goldfish in a blue bowl on the table; another time the table would be decorated with a lily. The "blue and white" was always in use for these dinners.

Illustration of a decorated Chinese porcelain jar with cover, 1878
Drawing, India ink and watercolor on paper, 21.8 x 16.2 cm (8⁹⁄₁₆ x 6⅜ in.)
Freer Gallery of Art, Smithsonian Institution

A lady asked him what would happen if one of the plates were to be smashed. "Why then—you know, we might as well all take hands and go and throw ourselves into the Thames!"

It was his mother's economies that enabled him to indulge his taste for collecting. When she first came to live with him, Whistler was working on a group of paintings in which European models were surrounded with Oriental pieces from his collection. The entire collection was sold when Whistler went bankrupt in 1879. After his marriage in 1888 he began to collect china again, and fine Georgian silver as well, to grace his table, but he could never match the quality of the pieces in this early collection, bought when they were comparatively unknown and cheap.

In February 1867 Whistler and his mother moved to another house on Lindsey Row, No. 2. She had not been seeing much of James. In 1866 he had gone to Valparaiso at the time of the civil war, and she went to live near Willie. Shortly after moving into No. 2, in April 1867, James was in Paris with Willie to attend the big Exposition when they suddenly became involved in a family row. There had been minor disagreements with Seymour Haden for years, and these culminated in Paris, with James pushing Haden through a plate glass window. They never spoke to each other again. Mrs. Whistler sided with her sons. Her only regret was that she was no longer free to see Deborah and her grandchildren. Perhaps to avoid the consequences of the family row, as well as to clear up business affairs left unsettled, she returned to the States for several months. Whistler was also upset by the quarrel. For several years he found it very difficult to complete paintings that had been commissioned, although he worked and

reworked the paintings he had on hand to perfect them.

Eventually it was his own mother who provided a subject that he understood completely and could paint to his own satisfaction. He had tried to paint her once already, and he had done a lovely drypoint of her standing up and looking at him with a slightly quizzical, tolerant expression.

One day in the summer of 1871 when a model failed to turn up so that he could complete another painting, Whistler turned to his mother and said:

Mother I want you to stand for me! it is what I have long intended & desired to do, to take your Portrait.

She was not strong enough to pose standing, so she sat at her ease. No artist had a more patient or interested sitter. The work took three months, painting, rubbing out, perfecting the outline of the figure and the textures of skin and lace, of the embroidered curtain and woven matting, giving the whole picture a unity that belied the months of work. She wrote to her sister Kate Palmer on November 3, 1871, when the portrait was complete:

…Jemie had no nervous fears in painting his Mothers portrait for it was to please himself & not to be paid for in other coin, only at one or two difficult points when I heard him ejaculate "No! I can't get it right! it is impossible to do it as it ought to be done perfectly!" I silently lifted my heart, that it might be as the Net cast down in the Lake at the Lords will, as I observed his trying again, and oh my grateful rejoicing in spirit as suddenly my dear Son would exclaim, "Oh Mother it is mastered, it is beautiful!" and he would kiss me for it!

They had shown the painting to a few friends. It was an unqualified success with them, but when it was sent to the Royal Academy the following year, it was nearly rejected. It was twenty years before it was bought by the Musée du Luxembourg, to go after Whistler's death to the Louvre. It was a bitter struggle for Whistler to get his work accepted, and it was a struggle for his mother to keep house while he could not sell his work.

She helped as much as she could to entertain those patrons who still admired his work. The banker W. C. Alexander commissioned Whistler to paint his children. In November 1872 Mrs. Whistler wrote:

> The Alexander portrait is nearly completed. little Cecily is standing now, & luncheon is being kept hot in the plate warmer at this fireside, as it was yesterday 2 hours til he could break off! of course she is not starving, for before she goes to the Studio I refresh her here with cake & milk, & she <u>enjoys</u> luncheon!

The little girl remembered, many years later, how Mrs. Whistler would never come up to the studio, and there were terrible delays before she got her lunch, and that "we had hot biscuits and tinned peaches, and other unwholesome things." She would often be crying with fatigue and hunger before Whistler would stop. There were over seventy sittings before the lovely painting was completed. The portrait is now in the Tate Gallery, a harmonious evocation of rather sulky childhood. The Alexanders liked Mrs. Whistler. They invited her to stay with them and sent her fresh fruit:

Soupe à Trois Sous
Etching, 15.3 x 22.7 cm (6¼ x 8¹⁵⁄₁₆ in.)
Freer Gallery of Art, Smithsonian Institution

…hot house Grapes, Peaches & Nectarines, which I have been so thankful to share with a few invalid neighbours…I could not have bought either fruit and even Apples so scarce & high priced…Mrs Alexander brought me a basket of Pears, such a boon! & two bunches of delicious Grapes.

F. R. Leyland, the Liverpool shipowner, also commissioned Whistler to paint his family. Whistler stayed with them for months at Speke Hall, working on the portraits, and his mother enjoyed a much-needed rest there. Mrs. Whistler was not in very good health. The summer's heat and winter fogs of London sapped her strength. In April 1872 she was convalescing:

When Mrs. Leyland came last week to stand day after day in the Studio for her Portrait, she of course came up to my room first, as I was yet confined to it. One day she sent up a large Satchel containing a pr of chickens, Asparagus, a doz "Natives" a bottle of best old Port wine & ditto of Cogniac such as I could not buy. The Oysters were the first thing I had relished.

Leyland had advanced several hundred pounds on the portraits and on other paintings that also remained incomplete month after month, year after year. Whistler got his mother to write and apologize. The Leylands continued to be generous. In November

> there came from Speke Hall a box directed to me, 6 bottles of best Old Port & 6 of champagne with 2 braces of Pheasants, & a loving note from dear Mrs. Leyland, you may be sure I am taking only a "little wine for health sake."

When Whistler's mother became less able to direct affairs, Whistler had to cut down on the amount of entertaining he did. Willie was also having difficulties, so he could not help out. Whistler's portrait of his mother was nearly seized by Willie's creditors in 1874, and it was then used by Whistler as security for a series of loans in an attempt to remain solvent.

All the same, his mother's small income meant they could afford at least one maid. It was not always easy "to obtain a good Cook of sobriety & neatness & skill." One maid went mad and threatened everyone with a knife, and for a while after that Mrs. Whistler was bothered by a series of teenage girls who had to be taught how to cook and wait. Eventually

she found a good maid of all work, Lucy, who worked with her for three years and continued with her even after marriage.

> I give Lucy 10/- and she finds her own meals—I took a motherly interest in her modest preparations for her wedding, giving her the ingredients to make and bake a generous large Cake, icing & all! a success!

For a while Whistler had a French couple at 2 Lindsey Row, Honoré and Florine, and toward the end of 1872 he was able to have both a footman and a cook. Whistler is said to have called his servants by the names of members of the Royal Academy so that he could order Frith to wait at table or Leighton to pour the wine, and so on. He did not expect the standard of sobriety that his mother did and would not employ a cook who claimed that she did not drink. "All good cooks drink!"

Mrs. Cossins was no exception. On November 7, 1881, two years after she had left his service, Whistler wrote an honest letter of recommendation to a lady thinking of employing Mrs. Cossins as cook:

> It is perfectly true that Mrs. Cossins was for four years in Mr. Whistler's service as cook and housekeeper with her husband as butler…Mrs. Cossins was one of the best cooks in London—so very good was her cooking that possibly more indulgence may have been shown to her than another with her faults would have received— meanwhile she was good tempered enough—and willing—and honest—if not always strictly sober—

Terry's Fruitshop
© Hunterian Art Gallery, University of Glasgow
Birnie Philip Gift

In the summer of 1874 Whistler redecorated 2 Lindsey Row, painting the walls in white and yellow. "You would be delighted at its brightness in tinted walls & staircase," wrote his mother. His friend C. A. Howell was less admiring. To go and see Whistler, he said, was like standing inside an egg.

The decorations were not finished when he gave his first dinner party. Walter Greaves, the son of a local boat builder, who was a "pupil" of Whistler's, was helping to paint the drawing room. One of his father's workmen was sent to Mme. Venturi to borrow pots and pans. Nelly's brother Luke remembered buying chairs and cheap wine, while the wife of another patron, F. R. Leyland, with her sister (who was, briefly, Whistler's fiancée), put up muslin curtains. Greaves could see it

would not be ready in time. "What matter?" said Whistler. "It will be beautiful!"

Whistler's mother had been seriously ill each winter for several years. In February 1875 she nearly died. Each time, Willie nursed her back to health. Now they realized that if she stayed in London she would not see another winter. She went to stay in Hastings and was lucky to find herself with the kindest of landladies. Her days were peaceful and she was contented. Her family came to visit her. James brought his Nocturnes to show her, and she appreciated them far more than the critics did. She left her precious book of recipes with James. "Mrs Cossins has made the most perfect pickles from your receipt," he wrote to her fondly.

Without his mother's restraining presence Whistler began to entertain lavishly. Maud Franklin, who had replaced Jo as his mistress and model, presided. On September 4, 1875, S. P. Avery, an American who was an enthusiastic collector of Whistler's etchings, noted briefly in his diary, "To Whistler to dine, Morris and Moore and artists and others present. Mrs. Whistler sick at Hastings—remained until 1 o'clock." Phil Morris and Albert Moore were regular guests. So were other artists—old friends of Paris days, Du Maurier, Lamont, Tom Armstrong, Tissot. On November 16, 1875, Alan Cole, son of Sir Henry Cole of the new South Kensington Museum, described the evening: "Dined with Jimmy; Tissot, A. Moore and Captain Crabb. Lovely blue and white china—and capital small dinner. General conversation and ideas on art unfettered by principles. Lovely Japanese lacquer."

Whistler is said to have invited an Italian landscape painter to "breakfast" one day. After spending half a crown on cab fare,

the guest was disgusted with his lunch: "Goldfish in bowl. Very pretty. But breakfast! One egg, one toast, no more." And he had to spend another half crown to get home! But reading through the menus that Whistler wrote out every day, the "capital small dinners"—large and elaborate by present-day standards—were the rule. These menus he signed with his butterfly monogram "JW" and preserved, as if they were drawings, in an old Japanese cabinet. There are more than a hundred in the Whistler collection at the University of Glasgow.

Allan Cole and Tissot were his guests again on December 7, 1875, together with the American artist G. A. Storey and Cyril Flower (later Lord Battersea). "Don't dare eat anything before you come—" Whistler told Allan Cole. The menu was a delicious mixture of American and English cooking, with a seasonal flavor:

Potage au homard − Harengs − sauce au vin rouge −
Côtelettes de Mouton, purée Champignons −
Poulet à la Baltimore − Homony − Bécassines −
Agourtzies − Mince pies − Compote de Poires −
Café − Brie − Salade

Lobster soup and snipe were luxuries even then, and they were no flash in the pan. On December 15, 1875, Armstrong and Lamont and Moore came to dine. The menu was a great contrast to their student fare in Paris nearly twenty years previously:

Potage au homard − Agourtzies − Sole frites − Côtelettes
de Mouton − purée de Champignons − Poulet en
Casserole − Undercut − Bétraves −
Pommes frites − Salade de Céleri −
Compote de Pommes − Brie − Café − Cigarettes

March 25

Potage printanier, aux quenelles.

Maquereau sur grille. sauce Whistler

Kransouskis. aux huitres.

Cotelettes de Mouton, purée d'Or.

Difleteé à la Parisienne.

Canards Sauvages.

Aspic de celeri.

Petite patisserie.

Omelette au Rhum.

Café.

Menu (in Whistler's handwriting) for one of his
"Sunday breakfasts," c. 1876
Photograph courtesy Glasgow University Library

Some of the dinners were more economical, with dishes of macaroni, fish cakes made with whiting and "potage bonne femme."

The specialties of the house included "Sauce Whistler" to go with mackerel and "Quenelles de Merlan à la Lindsey Houses." And there was one memorable meal that Whistler composed in artistic terms, the herring becoming a "note rouge," the fish cakes "en harmonie," the mushrooms a "purée d'Or"!

Mortimer Menpes described Whistler cooking up an omelette or a sauce while his guests waited. He was too particular; the food got cold while the sauce was being prepared. "Whistler cooked, as he painted, with marvellous skill and genius, but with great uncertainty." And not everyone appreciated tinted rice pudding and butter stained apple green to harmonize with the china. American dishes—tomato soup and oysters "à l'Americaine," "Potage-Nouvelle Orléans," apple pie, and buckwheat cakes "hot & hot" cooked by Whistler and served with molasses—were a special feature of the menus, in the family tradition.

The "Sunday breakfasts" became a regular and fashionable salon. The invitation might say midday, but Whistler was notoriously unpunctual. On one occasion a dozen guests were kept waiting. Eventually Howell came in to reassure them— Whistler was just having his bath!—and he came in, the perfect host, at half-past one. He was a good storyteller, and while he poured the wine and passed the food he would talk and talk, and there were so many pauses and exclamations and so much laughter that one story could take the entire meal.

Among the guests were Whistler's own "pupils," the Greaves brothers, and, later, Mortimer Menpes and Walter Sickert. As

well as artists, there were architects: E. W. Godwin—who had been commissioned by Whistler to build him a new house and studio, the White House in Tite Street, which he could certainly not afford—and his wife, Beatrice, who married Whistler in 1888 after Godwin's death; and Thomas Jeckyll, who had designed the dining room in F. R. Leyland's London house, which Whistler's decorations turned into the splendid Peacock Room. Expatriate Americans were invited. The painter George Boughton thought the "breakfasts" were "as original as himself or his work, and equally memorable." The guests came from all walks of life.

There were the stars of the theater, from "Corney" Grain to the lovely Lily Langtry. Lady Valerie Meux and Lady Archibald Campbell, who were painted by Whistler; H. H. Hurlbert and Sir Rennell Rodd; and others of diplomatic and Court circles made the "breakfasts" fashionable. Sir Rennell Rodd remembered "the inevitable buckwheat cakes, and green corn, and brilliant talk." Oscar Wilde provided his share of the brilliance.

Although Whistler rarely mixed work and entertainment, he occasionally succumbed to the temptation provided by his guests. On July 22, 1877, Mrs. Louise Jopling-Rowe, herself a popular portrait painter, was persuaded after "breakfast" to pose for Whistler. She looked splendid in a pale cream satin dress with full skirts gathered into a bustle, posed with her back to the artist and her face in profile, a "Harmony in Black and Flesh-colour." She stood for two hours without a rest while he painted a life-size full-length portrait. Godwin was present and noted in his diary that it was "An almost awful exhibition of nervous power and concentration." Not all the guests were impressed. They had planned an excursion. When they got

restless, Whistler was annoyed. "By Jove," he said, "it's not before every one that I would paint a picture." He kept the picture, although even the sitter assumed he had destroyed it, and it is now at the University of Glasgow.

Godwin was present later in the same year, on November 24, 1877, at a "breakfast" with Howell, Pellegrini, and Sir Garnet (later Lord) Wolseley. After lunch—"Potage aux tomates – Pigeons en compotes – Boeuf braisé Provencale" followed by coffee and mince pies—Whistler etched a drypoint portrait of Sir Garnet, a very effective profile of the distinguished commander. Beyond memories of "an agreeable luncheon at his house in Chelsea," Sir Garnet did not remember sitting for Whistler.

At Whistler's breakfasts the talk was good, the food was good, but Whistler could not afford wine to match. He sent Menpes out to buy white wine at 18d a bottle from the Victoria Wine Co., saying that men tended to know a good red wine when they drank it but to know far less about white. Luke Ionides helped Whistler put seals of three different colors on bottles of the same wine to impress a prospective client. The bottle with the red seal was served with the fish, the one with the blue seal with the meat, and so on! Shortly before Whistler went bankrupt, his various creditors were pressing for payment. A Mr. Chapman, who had made Whistler's picture frames, came in person to seek payment. He expressed surprise that Whistler could not pay his bills but was able to give him champagne. "Don't worry," said Whistler. "I don't pay for that either."

In 1879 Whistler moved into his new house on Tite Street, the White House. The bailiffs moved in with him. The walls were plastered with bills. The bailiffs helped serve the "Sunday

breakfasts." "You know I had to put them to some use!" said Whistler. His guests were impressed with his new servants. They were so efficient and attentive. "Oh, yes," said Whistler. "I assure you they wouldn't leave me."

A bill for £600 is said to have accumulated at the greengrocer's. Whistler met a demand for payment with his customary effrontery:

> …you have sent these things—most excellent things— and they have been eaten, you know, by most excellent people. Think what a splendid advertisement. And sometimes, you know, the salads are not quite up to the mark—the fruit, you know, not quite fresh. And if you go into these unseemly discussions about the bill—well, you know, I shall have to go into discussion about all this—and think how it would hurt your reputation with all these extraordinary people. I think the best thing is not to refer to the past—I'll let it go. And in the future, we'll have a weekly account—wiser you know!

According to Whistler's biographers, the Pennells, the grocer received two Nocturnes and a painting of Valparaiso in payment.

His bill with the fishmonger was also very impressive. His account ran from July 31, 1876, until January 17, 1879. Threepence for shrimp; sixpence for sprats and bloaters; a shilling's worth of haddock or kipper, whiting, salt cod, mackerel, or sole—or ice; four shillings for a dressed crab; lobsters and oysters from three to eight shillings; and, for a dinner party, the more expensive fish, cod, or mullet, at ten shillings, £1 for salmon, and £2.10 for turbot. But how they accumulated, all these little bills, to a terrible total of £88.10.3!

K'ang Hsi teapot owned by James McNeill Whistler
© Hunterian Art Gallery, University of Glasgow, Birnie Philip Bequest

In May 1879 Whistler was declared bankrupt, with liabilities of £4641.9.3 and assets of £1824. The sale of his furniture and household effects at the White House took place on September 18, 1879. He had not been one to accumulate a vast amount of personal property. The list of items for sale is rather pitiful, but it is interesting too, providing a comprehensive list of the contents of kitchen and pantry, down to the last tea tray. The kitchen was in the basement and was carpeted with eighteen yards of cocoa matting and furnished with a stout deal table, a Windsor chair, and an iron charcoal stove. Into the sale went:

Lot 124 Two pieces of carpet, coffee mill, 2 coffee pots
and a chocolate ditto

125 Four copper moulds, a copper saucepan, 2 strainers, frying basket, knife tray, 2 toasting forks, 2 jugs, tea tray and 2 tea caddies

126 A set of scales and weights, colander, zinc bowl, strainer and 6 baking tins

127 Thirteen saucepans in sizes

128 Three frying pans, 2 gridirons, deal plate racks and 30 pieces of crockery

129 Two tubs, 2 pails, 2 candlesticks, hot water can, 3 mats, crumb brush, slice, rolling pin and chopper

130 Six moulds, 3 hooks, 6 iron spoons, wooden spoon, knife board, piece cocoa matting and a mat

Even the cook had to go. Mrs. Cossins went to work for the sculptor J. E. Böehm. He recognized her apprenticeship at once from the salad, "a symphony in tomatoes," which she prepared on her very first day.

Whistler did not stay for the sale. The Fine Art Society advanced him money to go to Venice to make a set of twelve etchings for them. He spent over a year in Venice. Maud was with him, and although they were poor they still held Sunday "breakfasts," sometimes in a trattoria near the Via Garibaldi, sometimes with Whistler cooking tasty dishes over a spirit lamp in his rooms in the Casa Jankowitz on the Riva Schiavoni. A crowd of young Americans, Otto Bacher, Harper Pennington, J. W. Alexander, pupils of Duveneck, assembled to eat the land-lady's version of "Polenta à l' Américaine" with golden syrup. Fortunately, the fish and the wine were both cheap and good. Whistler was not in the least depressed by his misfortunes.

Whistler returned to London late in 1880 and went to stay with his brother on Wimpole Street while he printed and exhibited his etchings of Venice. But the success of an exhibition of his pastels of Venice at the Fine Art Society, which was to reestablish his reputation as an artist, was marred by the death of his mother at Hastings on January 31, 1881. Stricken with grief, the brothers attended her funeral. Whistler felt he had not lived up to her hopes and belief in him. Yet she had encouraged him and understood him as no one else could have done and had been as proud of him as he was of her. The finest testimony of their affection is the lovely portrait in the Louvre. "Yes," said Whistler one day to an artist who was admiring the picture, "one does like to make one's mummy just as nice as possible!"

There were still years of conflict ahead for Whistler. His work was received by the critics with suspicion and by the public, sometimes, with amusement. But the fashionable ladies who had come to his "breakfasts" now came to have their portraits painted. A younger generation of artists became his ardent supporters. Within a few years Whistler felt himself reestablished as an artist in London. His "breakfasts" were more brilliant than ever. Yet Whistler was rather worn out by the long battle with the British press and public. He decided to settle in Paris, where he had always been well received. His life had changed again for the better. On August 11, 1888, he married Beatrice Godwin. At the wedding breakfast Whistler refused to have the wedding cake at the table with them, it was so ugly, so it was unceremoniously left on the sofa. They spent their honeymoon in France and then began to look for a house. Eventually they found a pretty house and garden at 110

rue du Bac. There Beatrice presided over a procession of guests, old friends from Paris or Londoners over for the day, and Americans coming to ask Whistler to paint their portraits. As a host Whistler was as charming as ever, and as erratic. Beatrice was not too confident speaking French, and one guest remembered coming to dinner at 8 P.M. to find Beatrice with the poet Stéphane Mallarmé and his wife. Mme. Mallarmé could speak no English, and Whistler did not turn up until half past nine.

There were only a few years of peace and contentment in Paris. Then Beatrice fell ill and they returned to London. After an agonizing year she died of cancer, on July 10, 1896. Whistler took refuge in work. He had a new studio at 8 Fitzroy Street, where the landlady, Mrs. Burkitt, looked after him quite well. She had two young daughters, who both posed for Whistler. Her successor was less satisfactory. Mrs. Willis drank gin to excess. The whole family drank gin, even their curly-haired daughter Lizzie, whom Whistler also painted, so he called her portrait "Little Juniper Bud." At first, after his wife's death, Whistler went to live with friends and commuted restlessly between his home and studios in London and Paris. Then his sister-in-law came to keep house for him and looked after him until his death. He died on July 17, 1903, at 74 Cheyne Walk in Chelsea, only a few doors from the house he had shared with his mother some forty years previously.

THE RECIPES
· · · · · · · · · · · · · ·

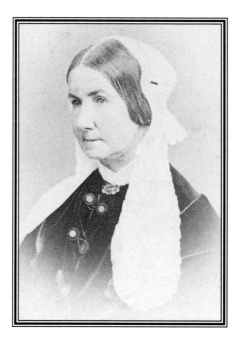

Anna McNeill Whistler
Photograph by F. Weisbrod
Photograph courtesy Glasgow University Library

NOTES FOR THE COOK
.

The original recipes from Mrs. Whistler's "Bible" are reprinted, with all their quaint spelling and punctuation, in italics. Underneath each is a tried and tested adaptation for the modern cook.

QUANTITIES

Households in Mrs. Whistler's day were large, and the amounts given in her recipes are correspondingly so. In most recipes, all the ingredients can be halved or quartered in proportion if smaller quantities are required.

FLOUR

Flour in Mrs. Whistler's time, although called "white," was probably nearer to what would now be called "wheat meal," which is an 81 percent or 85 percent extraction of the wheat grain. This is coarser than plain white flour, since it contains all the germ of the wheat, but is far less coarse and dark than what is now called "whole meal" or "whole wheat" flour.

If a wheat meal flour cannot be obtained, a plain white

flour will work equally well in all the recipes.

CAKE-MAKING

Many of the cakes are large and rich, and for these all the tins should be prepared in the following way, unless otherwise stated in the recipe.

Line cake tins with buttered greaseproof paper, putting a double layer on the bottom, with butter between the layers. To prevent the edges of the cakes from burning, tie a double thickness of brown paper around the outside of the tin. While baking, put several layers of brown paper or newspaper under the base of the tin.

Before starting to make either sponges or yeast cakes and buns, make sure the equipment and ingredients are warm.

YEAST

One packet of baker's yeast is the equivalent of 1 ounce (15 grams) of fresh yeast, or ½ ounce (10 grams) dried.

Compressed yeast was relatively unknown in Mrs. Whistler's time. Most housewives either skimmed off the excess yeast when they brewed beer (which was an everyday task in nearly every household) or made their own liquid yeast with grain mash, malted barley, or potatoes, sometimes adding hops and sugar. This is what Mrs. Whistler called "emptins." The results varied in strength and flavor. Emptins were generally not as strong as the yeast we buy today, and consequently some of the richer doughs needed longer to rise. Yeast mixtures will rise best in a room temperature of about 70°F.

Pearl ash

This is commercial potassium carbonate. Use baking powder for the same effect. Pearl ash was discovered in America in the 1790s and used until baking powder was produced in the 1850s.

Rose-water

This can be bought in any good pharmacy or in gourmet shops.

CONVERSION TABLES

Liquid Measures

METRIC (MILLILITERS)	IMPERIAL (FLUID OUNCES)	AMERICAN CUPS
50	2	¼ CUP
100 AND 125	4	½ CUP
150	5—¼ PINT	⅝ CUP
175	6	¾ CUP
225	8	1 CUP
250 AND 275	10—½ PINT	1¼ CUPS
325 AND 350	12	1½ CUPS
400 AND 425	15—¾ PINT	
450	16	2 CUPS
500	18	2¼ CUPS
550 AND 575	20—1 PINT	2½ CUPS

Solid Measures

COMMODITY	METRIC (GRAMS)	IMPERIAL (OUNCES)	CUPS
81% OR 85% FLOUR	125	4	1 CUP
SUGAR	225	8	1 CUP
SYRUP AND MOLASSES	275	10	1 CUP
BUTTER	225	8	1 CUP
DRIED FRUIT	175	6	1 CUP
YEAST (FRESH)	25	1	1 PACKET BAKER'S
YEAST (DRIED)	15	½	1 PACKET BAKER'S

Soups

· · · · · · · · · · · · ·

CHOWDER FISH

Take pickle pork cut very fine fry it add onions sliced.
let them fry with the pork. add the water you judge will be wanted,
let it boil slowly. put in your fish with black pepper and powdered
crackers. let it simmer slowly three-quarters of an hour.
just before serving put in Pilot Bread wet in cold water.

8 OUNCES SALT BELLY OF PORK	**2 LARGE ONIONS, THINLY SLICED**	**2 OUNCES CRUMBLED CRACKERS OR WATER DISCUITS**
1 ½ POUNDS WHITE FISH FILLETS (WHITING, HADDOCK, COD, ETC.)	**5 CUPS COLD WATER**	**4 WHOLE MEAL BISCUITS**
	¼ TEASPOON GROUND BLACK PEPPER	

Soak the pork in cold water overnight. Change the water and bring the pork slowly to the boil. Drain. Rinse with cold water and drain again. Cut away the rind and bones and dice the meat. Skin the fish and cut it into thin strips. Put the pork in a large saucepan and set it on low heat. When the fat begins to run, mix in the onions and cook them until they are

soft and beginning to brown. Pour in the water and bring it to the boil. Add the pepper and cracker or biscuit crumbs. Cover and simmer for 45 minutes. Break up the whole meal biscuits and soak them in cold water while the soup is cooking. Add them to the saucepan just before serving.

Serves 4 as a main course and 6–8 as a first course.

≈

A thick, satisfying chowder and full of flavor even though the basic ingredients are simple. Pilot bread was like a hard, whole meal ship's biscuit.

SOUP MAIGRE

put half pound of Butter into a deep stew-pan. shake it about untill it has done hissing. have six onions, shred, throw them in and shake them about. a bunch of celery cut small. a handful of spinach. a good lettuce a little parsley. stir it and let it stew a quarter of an hour. some pounded crackers a little pepper. the yolks of two eggs and three pints water. a little vinegar, a few green pease if you have them.

1 CUP BUTTER	1 LARGE LEAFY LETTUCE, FINELY CHOPPED	7½ CUPS WATER
6 MEDIUM ONIONS, FINELY CHOPPED	4 TABLESPOONS FRESH CHOPPED PARSLEY	3 TABLESPOONS TARRAGON OR WHITE WINE VINEGAR
1 SMALL HEAD CELERY, FINELY CHOPPED	½ CUP SHELLED PEAS	SALT AND FRESHLY GROUND BLACK PEPPER
20 SPINACH LEAVES, FINELY CHOPPED	6 SMALL CRACKERS OR WATER BISCUITS, CRUSHED	2 EGG YOLKS

M elt the butter in a saucepan on medium heat. When the foam has subsided, stir in the onions, celery, spinach,

lettuce, parsley, and peas. Cover and cook gently for 15 minutes. While the vegetables are cooking, soak the crushed crackers in the water and vinegar. Uncover the vegetables and stir in the soaked biscuits and liquid. Salt and pepper to taste. Bring the soup to the boil and simmer, uncovered, for 15 minutes. Take the pan from the heat. Whisk the egg yolks to a cream in a bowl and gradually beat in 6 tablespoonsful of the hot soup. Return the liquid to the saucepan and reheat gently, without boiling, until it thickens slightly.

Serves 8.

The fresh vegetables give this creamy soup a deliciously refreshing flavor.

PEASE SOUP

To one quart of split peas put a gallon of soft water
boil them slowly with some celery a small bunch of sweet herbs and
some cayenne peper when nearly boiled add a peice of pickled pork
that is boiled in fresh water let them boil together some minutes
add a lump of butter when dished.

2 POUNDS SALT BELLY OF PORK	20 CUPS WATER	LARGE BOUQUET GARNI (PARSLEY, MARJORAM, THYME, BAY LEAF)
WATER TO COVER	5 CUPS GREEN SPLIT PEAS	
2 TEASPOONS BLACK PEPPERCORNS	1 SMALL HEAD CELERY, FINELY CHOPPED	2 TEASPOONS CAYENNE PEPPER
BOUQUET GARNI (PARSLEY, THYME, BAY LEAF)		1 TEASPOON BUTTER PER DISH WHEN SERVING

Cook the pork before you start to make the soup. Put it into a saucepan of cold water. Bring to the boil and drain. Rinse it with cold water and drain again. Return it to the saucepan with the peppercorns and bouquet garni. Cover it with cold water. Bring to the boil and skim. Cover and simmer 1 hour. Lift out the pork. Remove the rind and bones and dice the meat finely.

To make the soup, bring the water to the boil in a large saucepan. Put in the peas, celery, and large bouquet garni. Season with cayenne pepper. Cover and simmer for 45 minutes. Remove the bouquet garni. Add the diced pork. Cover and simmer for 15 minutes. Pour the soup into serving bowls and top each one with a teaspoonful of butter.

Serves 20 as a lunch or supper dish.

A thick, nourishing soup with a delicious flavor. It makes a very good winter supper. Sweet herbs include parsley, thyme, marjoram, summer savory, chervil, and possibly basil. Herbs such as sage, with a definite bitter quality, should not be included.

BROWN SOUP

Take the remains of any cold fresh meat after it is cooked, chop the bones and meat small, boil them slowly untill the quantity of liquid you wish tastes strongly of the meat. strain it, season with sweet Herbs, savory, cloves, pepper onion salt, a little wine and catsup. thicken with Brown Flour and Butter. if you have different kinds of cold meat—knuckles of meat &c. they will make the soup still better

1 CHICKEN, TURKEY, DUCK, OR GOOSE CARCASS FROM A ROASTED BIRD	2 BAY LEAVES	TO EVERY 3 CUPS STRAINED LIQUID:
ANY OTHER COOKED BEEF OR LAMB BONES IF AVAILABLE	1 TABLESPOON BLACK PEPPERCORNS	1 TABLESPOON BUTTER
1 HAM KNUCKLEBONE	1 TABLESPOON WHOLE CLOVES	1 TABLESPOON FLOUR
1 LARGE ONION, SLICED	1 TEASPOON SALT	2 TABLESPOONS FRESH CHOPPED SAVORY, MARJORAM, PARSLEY, CHERVIL, AND THYME
BOUQUET GARNI (PARSLEY, THYME, MARJORAM)	WATER TO COVER	½ CUP DRY RED WINE
		1 TABLESPOON MUSHROOM (OR TOMATO) KETCHUP (CATSUP)

Put all the bones into a large saucepan or flameproof casserole with the onion, herbs, and spices. Cover them with water and bring them to the boil. Skim off any scum. Cover and boil gently for 1½ hours. Strain and measure the liquid. Set aside. Melt the butter in a saucepan on moderate heat. Remove the saucepan from the heat. Stir in the flour, return to the heat, and cook, still stirring, until it turns a deep russet brown. Remove from the heat and gradually stir in a ladle of stock. Return to the heat, stir in the rest of the stock, and bring to the boil. Add the mixed herbs, wine, and ketchup. Simmer, uncovered, for 10 minutes.

~

A clear, dark, richly flavored soup. It is a good way of using up the bones from the Christmas or Thanksgiving turkey. The quantity of soup depends on the size of the carcass and the amount of water used to cover the bones.

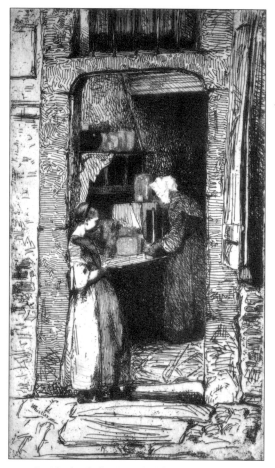

La Marchande de Moutarde (The Mustard Seller)
Etching, 15.7 x 9.0 cm (6⁷⁄₁₆ x 3⁹⁄₁₆ in.)
Freer Gallery of Art, Smithsonian Institution

FISH

· · · · · · · · · · · · ·

OISTERS

To two quarts of oisters a half pound of butter.
Drain the water from them carefully seeing if any particles of shell
adheres to the oister strain the water
let it boil, then add a spoonful of flour beat up smooth and boiled up.
then add whole peppers, the butter oister and toasted bread

48 OYSTERS	**4 TABLESPOONS WATER**	**4 OUNCES BREAD, SLICED**
1 TABLESPOON FLOUR	**1 CUP BUTTER**	**FRESHLY GROUND BLACK PEPPER**

Put a sieve over a bowl. Take the oysters from their shells and drop them into the sieve, letting all their liquid strain into the bowl. Run cold water through the oysters to remove any particles of shell. Beat the flour and water together to make a paste. Cut the butter into small pieces. Toast the bread and cut it into cubes. Bring the oyster liquid to the boil. Stir in the flour-and-water mixture and simmer until the liquid thickens.

Season with the pepper. Beat in the butter and let it melt. Add the oysters and cubes of toast and simmer for 1 minute. Serve in small bowls.

Serves 8 as a first course.

~~~

Lightly cooked oysters in a creamy pale yellow sauce that is full of flavor.

# COLLARD EELS

*Spread your eels upon a table and cut out the back bones,*
*then sprinkle them with salt and pepper, Cayenne, Marjoram and*
*Cloves at discretion   then roll them up and tie them round*
*to prevent their undoing, and boil them in vinegar and water.*
*When cold cut them in slices.*

| | | |
|---|---|---|
| 1 CONGER EEL, ABOUT 3 POUNDS | ½ TEASPOON GROUND BLACK PEPPER | 5 CUPS WATER |
| ½ TEASPOON SALT | ½ TEASPOON CAYENNE PEPPER | ½ CUP WHITE WINE VINEGAR |
| 2 TABLESPOONS FRESH CHOPPED MARJORAM | 8 WHOLE CLOVES | |

**G**et your fishmonger to head and gut the eel. Slit it down the belly and take out the backbone, keeping the eel in one piece. Sprinkle the inside with the salt, marjoram, black pepper, and cayenne pepper. Place the cloves at regular intervals down the length. Tie the eel into a sausage shape. Put the water and vinegar into a large saucepan and bring to the boil. Put in the eel and simmer it very gently for 30 minutes. Let it cool completely in the liquid. Serve cold, cut in thick slices.

Serves 8 as a first course or with salad as a main course.

A superb light dish of eel. The vinegar gives it a fresh taste with no hint of sharpness.

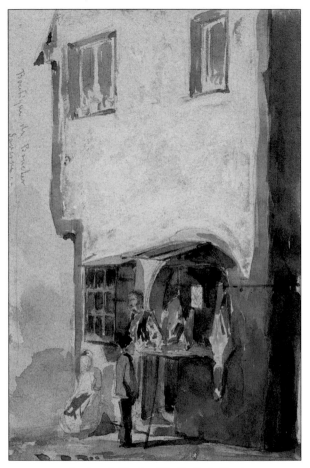

*Boutique de Boucher (The Butcher's Shop)*
Drawing, watercolor and pencil on paper, 21.7 x 14.4 cm (8⁹⁄₁₆ x 5¹¹⁄₁₆ in.)
Freer Gallery of Art, Smithsonian Institution

# Main Dishes

· · · · · · · · · · · · ·

## Chickens in Cream

*cut your chickens in the usual way, fry them in sweet lard of a fine brown, empty the lard from the frying pan, put the chickens to keep hot while you make your gravy. put to half a pint of thin cream about a quarter pound butter a little Flour, shake it in the frying pan, let it boil once, then put in the chickens, and serve them with parsley.*

| | | |
|---|---|---|
| 1 ROASTING CHICKEN, 3–3½ POUNDS DRESSED | ½ CUP BUTTER | 1¼ CUPS LIGHT OR SINGLE CREAM |
| 1 TABLESPOON LARD | 2 TABLESPOONS FLOUR | 4 TABLESPOONS FRESH CHOPPED PARSLEY |

**J**oint the chicken and divide into six or eight pieces. Heat the lard in a frying pan on moderate heat. Put in the chicken pieces, skin side down first, and cook them for 3 minutes on each side, until they are golden brown. Lower the heat and continue cooking for 20 minutes, turning the pieces occasionally. Put them in a dish and keep them warm. Pour all the fat from the pan. Put in the butter and melt on low heat. Take

the pan off the heat and stir in the flour. Stir in the cream and parsley and bring gently to the boil. Return the chicken pieces to the pan. Coat them with the sauce and simmer for 1 minute.

Serves 6.

≫

Chicken in a rich, creamy sauce that preserves its delicate flavor.

## ROAST PIG

*after fitting your Pig for the spit, fill the belly with a stuffing made of*
*Bread, butter, sage and sweet Herbs. roast it to a fine Brown.*
*Take it from the spit. have the inwards boiled and chaped fine, take*
*the stuffing from the pig, mix it with the mince   a lump of butter*
*a little pepper   put it over a chaffing dish a few minutes,*
*serve it for a side dish with the Pig.*

8 CUPS FRESH BREAD CRUMBS

1 CUP BUTTER

2 TABLESPOONS EACH FRESHLY CHOPPED SAGE, MARJORAM, AND THYME

4 TABLESPOONS FRESHLY CHOPPED PARSLEY

1 SUCKLING PIG, ABOUT 25 POUNDS DRESSED

2 TABLESPOONS BUTTER, SOFTENED

2 TABLESPOONS SALT

HEART, TONGUE, LIVER, LUNGS, BRAIN, AND SWEETBREADS FROM THE PIG

WATER TO COVER

FRESHLY GROUND BLACK PEPPER

2 TABLESPOONS BUTTER

*Oven at 390°F/200°C/Reg 6*

**P**ut the bread crumbs into a bowl. Melt the butter; mix it into the bread crumbs with the herbs. Fill the carcass of the pig with the stuffing and sew it up. Spread the outside of the pig with the softened butter and rub in the salt. Put the pig

into an uncovered roasting pan. Place it in the oven and roast it for 2½ hours; or, if you want to provide an outdoor feast, put it on a spit over an open fire and roast it for approximately 5 hours. (It is impossible to give the exact time for this method, as it will depend very much on the weather and the type of fire used.)

While the pig is cooking, prepare the heart, tongue, liver, and lungs by cutting off any tubes or gristle, and put them into a saucepan. Add water to cover. Bring to the boil and skim the surface. Simmer, covered, for 1½ hours. Boil the brain and sweetbreads in enough water to cover for 10 minutes, drain, and trim off any gristle. Lift out the rest of the meat. Skin the tongue. Chop everything finely.

Take the pig out of the oven or off the spit and lay it on a large dish. Take out all the stuffing and mix it with the chopped meat and pepper. Melt the butter in a large frying pan on high heat. Put in the stuffing, chop it into the butter and fry for 2 minutes. Put it into a warm serving dish.

Carve the pig and serve the stuffing separately. If desired, gravy can be made from the stock produced by boiling the giblets.

Serves 20–30.

≈

The meat from a suckling pig is soft, sweet, and tender. If it is roasted on a spit in the open, it will take on a characteristic smoky flavor.

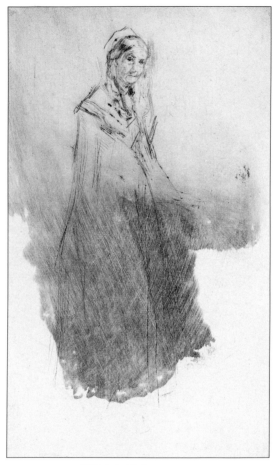

*Whistler's Mother,* 1870–1873
Print, drypoint, first state, 25.2 x 15.3 cm (9¹³⁄₁₆ x 6¹⁄₁₆ in.)
Freer Gallery of Art, Smithsonian Institution

# PUDDINGS

· · · · · · · · · · · · ·

## MARLBOROUGH PUDDING I

*Take the peel of 2 lemons and boil them in water, when the strength
is all boiled out stew 7 good apples in the water   when done stir in
¼ lb of butter, a little cream, 7 eggs   7 spoonsfull of sugar, nutmeg.*

RIND OF **2** LEMONS,
  THINLY PARED

1 ½ CUPS WATER

7 MEDIUM COOKING
  APPLES

½ CUP BUTTER

2 TABLESPOONS HEAVY
  OR DOUBLE CREAM

7 EGGS, BEATEN

7 TABLESPOONS SUGAR

½ NUTMEG, GRATED

*Oven at 350°F/180°C/Reg 4*

Simmer the lemon rind in the water for 30 minutes. Strain it
and reserve the water. Peel, core, and chop the apples. Put
them in a saucepan with the lemon water and simmer, covered,
for 15 minutes. Rub them through a sieve. Beat in the butter, cut
into small pieces, with the cream, eggs, sugar, and nutmeg. Pour
the mixture into a lightly buttered 8-cup ovenproof dish and bake
the pudding for 50 minutes, until it is set and golden.

Serves 12–16.

A rich and tasty golden pudding with a light texture.

# MARLBOROUGH PUDDING II

*To a pint of pulped apples add the juice of a Lemon and a little of the peel shred fine, 5 eggs and a gill of cream, half a pound of sugar, bake in a thin paste in a moderate oven.*

| | | |
|---|---|---|
| SHORTCRUST PASTRY MADE WITH 2 CUPS FLOUR | 2 TABLESPOONS WATER | 5 EGGS, BEATEN |
| | JUICE AND GRATED RIND OF 1 LEMON | ⅝ CUP HEAVY OR DOUBLE CREAM |
| 5 MEDIUM COOKING APPLES | 1 CUP SUGAR | |

*Oven at 350°F/180°C/Reg 4*

**M**ake the pastry. Peel, core, and chop the apples. Put them into a saucepan with the water. Cover and set on low heat for 15 minutes. Rub the apples through a sieve and beat in the lemon rind and juice, sugar, eggs, and cream. Roll out the pastry and line a 4-cup pie dish. Pour in the apple mixture and bake the pudding for 1 hour. Serve hot or cold.

Serves 12–14.

A light custard tart with a refreshing lemon flavor and soft, creamy texture.

# POTATOE PUDDING

*Two pounds of strained boil'd potatoes, mix in half a pound of melted*
*butter, half pound of sugar   the yolks of 8 eggs & the whites of 3*
*a pint of cream   a nutmeg, and some wine*

**2½ CUPS BOILED AND**
**SIEVED POTATOES**

**1 CUP BUTTER, MELTED**

**1 CUP SUGAR**

**3 EGGS, BEATEN**

**5 EGG YOLKS, BEATEN**

**2½ CUPS HEAVY OR**
**DOUBLE CREAM**

**½ CUP SWEET WHITE**
**WINE**

**1 NUTMEG, GRATED**

*Oven at 390°F/200°C/Reg 6*

**P**ut the potatoes into a bowl and beat in the butter, sugar,
eggs, yolks, cream, wine, and nutmeg until you have a
smooth batter. Pour it into a buttered 16-cup ovenproof dish
and bake the pudding for 1 hour.

Serves 25–30.

❧

A golden brown pudding, sweet and delicious, with the tex-
ture of light semolina, nicely flavored with nutmeg and wine.

# APPLE PUDDING I

*Boil and mash as many Potatoes as you judge nesecary, work in a*
*little salt and  Flour untill it is a stiff paste   roll it and spread it in*
*your pudding cloth, and fill it with apple pared and quartered,*
*a little orange   lemon or ciniamon. boil it two hours.*
*sauce sugar  Butter, rose-water*

| | | Sauce: |
|---|---|---|
| 1 POUND POTATOES | RIND OF 1 ORANGE, GRATED, OR GRATED RIND OF 1 LEMON OR ½ TEASPOON GROUND CINNAMON | ¼ CUP UNSALTED BUTTER |
| 1 TEASPOON SALT | | ¼ CUP SUGAR |
| 1½ CUPS FLOUR | | 2 TABLESPOONS ROSE-WATER |
| 3 MEDIUM COOKING APPLES | 2 TABLESPOONS SUGAR | |

**B**oil the potatoes in their skins. Peel them and rub them through a sieve. Beat in the salt and 1 cup of the flour to make a stiff dough. Scald a pudding cloth, lay it on a flat surface, and sprinkle it with the remaining flour. Put the dough in the center and roll it to about ¼ inch thick. Peel, quarter, and core the apples. Put the quarters into the center of the dough and sprinkle them with the grated orange, lemon rind, or cinnamon and the 2 tablespoonsful sugar. Bring the edges of the dough together and seal them well. Make sure the dough is not too thick where it has been joined. Gather the cloth around the pudding and tie it securely. Bring a large pan of water to the boil, lower in the pudding, and simmer, covered, for 2 hours. While it is cooking, make the sauce. Beat the butter until it is soft and then beat in the ¼ cup sugar. Beat in the rose-water drop by drop. When the pudding is done, lift it out of the saucepan into a colander and let any excess water drain away. Untie the cloth. Invert a bowl over the pudding and turn the colander over so the pudding drops easily into the bowl. Either cut a cross in the top of the pudding and insert the sauce in spoonfuls or serve the sauce in a separate dish.

Serves 8.

❧

A plain pudding for a hungry family. It has a surprisingly light-textured crust. The sweet, fragrant sauce subtly improves the flavor.

# AMHURST PUDDING

*6 oz sugar    6 eggs    5 apples    6 oz butter    a grated lemon and the
juice    two spoonsful of rosewater    spice to your taste.—*

| | | |
|---|---|---|
| **5 MEDIUM COOKING APPLES** | **GRATED RIND AND JUICE OF 1 LEMON** | **¼ TEASPOON CLOVES, GROUND** |
| **¾ CUP BUTTER** | **2 TABLESPOONS ROSE-WATER** | **6 EGGS** |
| **¾ CUP SUGAR** | | |

*Oven at 350°F/180°C/Reg 4*

**P**eel, core, and chop the apples. Melt 2 tablespoonsful of the butter in a saucepan on low heat. Stir in the apples. Cover and cook for about 15 minutes, until the apples are soft and pulpy. Rub them through a sieve. Return the purée to the saucepan and beat in the remaining butter and the sugar. Set the saucepan on very gentle heat and stir until the butter and sugar have dissolved. Take the pan from the heat and beat in the lemon rind and juice, the rose-water, and the cloves. Beat the eggs until they are frothy and fold them into the apple mixture. Pour the mixture into a buttered 8-cup ovenproof dish and bake for 45 minutes. Serve hot.

Serves 12–16.

≈

A rich, golden pudding with a fragrant flavor of lemon.

# PUNKIM PUDDING

*to a quart of punkim strained, add 8 eggs   a quart of new milk, a little*
*melted butter, a little ginger, nutmeg   cinamon and powdered orange Peel.*

| | | |
|---|---|---|
| 2½ POUNDS CHOPPED PUMPKIN (WEIGHED AFTER REMOVING SHELL AND SEEDS) | 5 CUPS MILK | 2 TEASPOONS GROUND CINNAMON |
| | 8 EGGS, BEATEN | ½ NUTMEG, GRATED |
| ½ CUP WATER | 2 TEASPOONS GROUND GINGER | RIND OF 1 ORANGE, GRATED |
| ¼ CUP BUTTER | | |

*Oven at 320°F/160°C/Reg 3*

**P**ut the pumpkin into a saucepan with the water. Cover and set it on low heat. Cook for about 20 minutes, until the pumpkin is soft and pulpy. Beat it to a purée. Melt the butter. Stir the butter, milk, eggs, spices, and grated orange rind into the pumpkin. Pour the mixture into a 12-cup oven-proof dish. Bake the pudding for 1½ hours.

Serves about 25.

≈

A spicy pudding with a light texture. It is rather like the filling of a pumpkin pie. The grated orange peel enhances the bland taste of the pumpkin.

# FEDERAL PUDDING

*One quart of milk scalded and a pound of flour stirred in & ½ lb*
*Butter, then let it stand till it is cold & add 8 eggs,*
*Sugar & spice to taste & the juice and peel of one lemon.*
*It may be eaten with or without sauce.*

| | | |
|---|---|---|
| 5 CUPS MILK | 8 EGGS | ¼ NUTMEG, GRATED |
| 1 CUP BUTTER | ½ CUP SUGAR | JUICE AND GRATED RIND OF 1 LEMON |
| 4 CUPS FLOUR | 1 TEASPOON GROUND CINNAMON | |

*Oven at 375°F/190°C/Reg 5*

**B**ring the milk to the boil and remove it from the heat. Melt the butter in a saucepan on moderate heat. Take the pan from the heat and stir in first the flour and then the milk. Stir on low heat until you have a thick, white sauce. Cover it with wet greaseproof paper and leave until it is cold. Beat in the eggs, sugar, spices, lemon rind, and juice. Pour the mixture into a buttered 8-cup pie dish and bake for 1 hour, until it is set and golden. Serve hot, quite plain or with cream or fruit sauce.

Serves 20.

A rich pudding, well flavored with spices and lemon.

## LEMON PUDDING I

*Grate the peel of 2 lemons    ¾ pound white sugar    12 yolks*
*6 whites of eggs well beat, soak 2 naples biscuits in a pint of cream*
*mix all together    put a sheet of paper at the bottom of the dish*
*when your oven is ready, put in your stuff*
*sift a little sugar over it    half an hour will bake it.—*

| | | |
|---|---|---|
| 10 SMALL SPONGE FINGER (BOUDOIR) BISCUITS | 2½ CUPS HEAVY OR DOUBLE CREAM | 1½ CUPS PLUS 1 TABLESPOON SUGAR |
| | 6 EGGS | RINDS OF 2 LEMONS, GRATED |
| | 6 EGG YOLKS | |

*Oven at 350°F/180°C/Reg 4*

**P**ut the biscuits into a paper bag and crush them to fine crumbs with a rolling pin. Put them in a bowl and stir in the cream. Leave them to soak for 30 minutes. Whisk the eggs, yolks, and 1½ cups sugar together until the mixture is fluffy. Fold in the soaked crumbs and lemon rind and mix everything together well. Pour the mixture into a lightly buttered 8-cup pie dish or other ovenproof dish and sprinkle the remaining tablespoonful of sugar over the top. Bake the pudding for 45 minutes.

Serves 12–16.

The pudding has a soft, spongy texture and a delicate lemon flavor.

## LEMON PUDDING II

*Take the juice of three lemons and the peel of two—
half a pound of sugar, ¼ of Butter   15 eggs   leave out eleven whites
mix it and put it over a slow fire—*

| | | |
|---|---|---|
| 4 EGGS | 1 CUP SUGAR | RINDS OF 2 LEMONS, GRATED |
| 11 EGG YOLKS | JUICE OF 3 LEMONS | ½ CUP BUTTER |

*Oven at 340°F/170°C/Reg 3*

**W**hisk the eggs and yolks together until they are frothy. Beat in the sugar, lemon juice, and rinds. Melt the butter on low heat. Cool it slightly and beat it into the eggs.

Pour the mixture into a buttered 4-cup ovenproof dish and bake the pudding for 45 minutes. Serve hot or cold.

Serves 12.

❧

A delicious bright yellow custard with a sweet lemon flavor and a deep brown top.

## COCOANUT PUDDING

*Peel and grate a large nut    dissolve half pound white sugar    put to it put these together ¼ hour    take 3 rusk or crackers    pound them fine put them to a pint of milk made hot    add the yolks of 8 eggs well beat    2 spoonsfull of melted butter    as much rose water, mix them all together, put it in a paste, bake it one hour.*

| | | |
|---|---|---|
| SHORTCRUST PASTRY MADE WITH 1½ CUPS FLOUR | 1 CUP SUGAR | 2 TABLESPOONS MELTED BUTTER |
| | 2½ CUPS MILK | |
| 1 LARGE COCONUT (3 CUPS GRATED) | 3 UNSWEETENED CRACKERS OR WATER BISCUITS | 2 TABLESPOONS ROSE-WATER |
| | | 8 EGG YOLKS |

*Oven at 350°F/180°C/Reg 4*

**M**ake the pastry. Take the coconut from the shell. Grate it finely. Put the coconut and sugar into a heavy saucepan with 1 cup of milk and set it on moderate heat for 15 minutes. Leave it to cool. Crumble the crackers or biscuits very finely. Put them in a saucepan with the remaining milk and bring to the boil. Cool slightly and mix with the coconut mixture. Beat in the butter and rose-water. Whisk the egg yolks until they are frothy and beat them into the coconut

mixture. Roll out the pastry and line a 5-cup shallow pie dish. Pour in the coconut filling and bake the pudding for 1 hour. Serve hot or cold.

Serves 12.

≈

A rich, golden tart with a creamy coconut flavor.

## APPLE PUDDING II

*Take 6 large apples strained, and six eggs, 6 oz butter   6 oz sugar some nutmeg   then put paste under and bake it.—*

| | | |
|---|---|---|
| SHORTCRUST PASTRY MADE WITH 2 CUPS FLOUR | 4 TABLESPOONS WATER | 6 EGGS, BEATEN |
| | ¾ CUP BUTTER | ½ NUTMEG, GRATED |
| 6 LARGE COOKING APPLES | ¾ CUP SUGAR | |

*Oven at 350°F/180°C/Reg 4*

**M**ake the pastry. Peel, core, and chop the apples and put them in a saucepan with the water. Cover and set on low heat for about 15 minutes, until they are soft. Rub them through a sieve. Cut the butter into small pieces, beat it into the apples, and let it melt. Beat in the sugar, eggs, and nutmeg. Roll out the pastry and line an 8-cup shallow pie dish. Pour in the apple mixture and bake the pudding for 1 hour.

Serves 12.

≈

A rich, golden apple pie with a delicious suggestion of nutmeg.

# CUSTARD PUDDING

*Mix a pint of cream with 6 eggs, two spoonsfull of flour, half a nutmeg, salt and sugar to your taste, butter your cloth when you put it in, when your pot boils your pudding will be done in half an hour.—*

| | | |
|---|---|---|
| **2 TABLESPOONS FLOUR** | **4 TABLESPOONS SUGAR** | **6 EGGS, BEATEN** |
| **PINCH OF SALT** | **½ NUTMEG, GRATED** | **2½ CUPS HEAVY OR DOUBLE CREAM** |

**P**ut the flour in a mixing bowl with the salt, sugar, and nutmeg. Beat in the eggs and cream. Pour the mixture into a buttered 4-cup pudding basin. Cover the top with buttered greaseproof paper and foil or a pudding cloth and tie down. Bring a saucepan of water to the boil and lower in the pudding. Cover the pan and simmer for 30 minutes. Lift out the pudding and leave for 5 minutes before serving directly from the basin.

Serves 8.

❦

A yellow pudding with the texture of a light custard and a pronounced nutmeg flavor.

# BAKED PLUMB PUDDING

*Take a pint bowl of dried bread pounded, or biscuits   three pints milk thicken your milk over the fire with the bread to prevent the raisins settling, when cold enough add a lb of beef suet chopd fine, 10 eggs, a pound & a half of raisins, quarter lb of sugar a little cinnamon, some cloves, & a glass of Brandy.*

| | | |
|---|---|---|
| 2½ CUPS DRIED BREAD CRUMBS OR BISCUIT CRUMBS | 10 EGGS, BEATEN | 1 TEASPOON GROUND CINNAMON |
| | 4 CUPS RAISINS | |
| 7½ CUPS MILK | ½ CUP SUGAR | 2 TEASPOONS CLOVES, GROUND |
| 1 POUND FRESH BEEF SUET | | ½ CUP BRANDY |

*Oven at 340°F/170°C/Reg 3*

**P**ut the bread or biscuit crumbs in a saucepan with the milk and bring gently to the boil. Leave to cool. Grate the suet or chop it very fine. Mix the suet, eggs, raisins, sugar, spices, and brandy into the milk and crumbs. Pour the mixture into a buttered 12-cup ovenproof basin. Bake the pudding for 1½ hours. Serve hot, either straight from the basin or turned out onto a large plate.

Serves 25.

❧

A light-textured fruit pudding, gently flavored with spices and not oversweet.

## PLUMB PUDDING

*One pound of beef suet chopd fine, three quarters pound stoned raisins, 1 nutmeg, 1 quarter pound sugar, a little brandy, 4 eggs, four spoonsful of cream, mix pretty stiff   tie it in a cloth tight and boil it 4 hours.—*

| | | |
|---|---|---|
| 1 POUND FRESH BEEF SUET | 1/2 CUP SUGAR | 4 TABLESPOONS HEAVY OR DOUBLE CREAM |
| 2 CUPS RAISINS | 4 TABLESPOONS BRANDY | 2 CUPS FLOUR PLUS ½ CUP FOR CLOTH |
| 1 NUTMEG, GRATED | 4 EGGS, BEATEN | |

**G** rate or chop the suet very finely. Mix all the ingredients together except the ½ cup flour for the cloth. Scald and flour a pudding cloth and tie all the ingredients in it tightly. Bring a large pan of water to the boil. Lower in the pudding and simmer, covered, for 4 hours, topping up the water as necessary. Lift out the pudding and lower it onto a colander to drain. Untie the cloth. Invert a dish over the top and turn the colander upside down so that the pudding falls into the dish. Serve hot.

Serves 15.

A fairly rich pudding with a good fruity flavor, needing no accompaniment. The perfect dish for a hungry family on a cold winter's day.

## BOILED PLUMB PUDDING

*9 eggs    a pound of Raisins stoned    a quarter of a pound of fresh*
*suet, the crumb of a sixpenny loaf    a quart of milk—*
*half pound of currants    cold sauce of sugar    Butter    white of a egg.*
*rubed smooth with nutmeg and wine—*

| | | |
|---|---|---|
| 5 CUPS FRESH BREAD CRUMBS | 2⅔ CUPS RAISINS | 1 CUP UNSALTED BUTTER |
| 5 CUPS MILK | 1⅓ CUPS CURRANTS | 1 CUP SUGAR |
| 4 OUNCES FRESH BEEF SUET | ½ CUP FLOUR FOR CLOTH | 1 NUTMEG, GRATED |
| 9 EGGS, BEATEN | SAUCE: | 6 TABLESPOONS SWEET WHITE WINE |
| | 1 EGG WHITE | |

**S** oak the bread crumbs in the milk. Grate the suet or chop it very fine. Mix all the ingredients together except the ½

cup flour for the cloth. Scald and flour a large pudding cloth and tie the pudding in it tightly. Bring a large pan of water to the boil. Lower in the pudding. Cover and simmer for 4 hours, topping up the water as necessary. While it is cooking, make the sauce. Stiffly whip the egg white. Beat the butter and sugar together until they are light and fluffy. Beat in the nutmeg, the egg white, and then the wine, 1 tablespoonful at a time. Put the sauce into a small bowl and chill. When the pudding is done, lift it from the saucepan and let it drain in a colander. Untie the cloth. Invert a dish over the top and turn the colander upside down so the pudding falls into it. Serve the pudding, cut into slices, with a spoonful of sauce on top of each slice.

Serves 20.

A fairly rich, semisweet pudding perfectly complemented by the sweet sauce, which melts into it and moistens it deliciously.

## BREAD-AND-BUTTER PUDDING

*Take half a sixpenny loaf. cut off the crust, spreading it with Butter in thin slices   butter a pudding dish. lay a layer of Bread and a layer of half a pound of currants   the same of raisins untill your dish is filled. beat five eggs with a quart of new milk   a quarter of a pound of sugar a glass of rose-water and pour over the Bread and Fruit. bake an hour. (sauce sugar wine nutmeg)*

| | | SAUCE: |
|---|---|---|
| 12 OUNCES BREAD | 5 EGGS | 2 CUPS SWEET WHITE WINE OR SHERRY |
| ½ CUP BUTTER, APPROXIMATELY | 5 CUPS MILK | |
| | 1 CUP SUGAR | ½ CUP SUGAR |
| 4 CUPS RAISINS | ½ CUP ROSE-WATER | 1 NUTMEG, GRATED |
| 4 CUPS CURRANTS | | |

*Oven at 350°F/180°C/Reg 4*

**S**lice the bread thinly. Butter each slice and cut off the crusts. Cut each slice into quarters. Butter a 12-cup ovenproof dish. Put in one layer of bread, butter side up, and spread over it one-third of the raisins and currants mixed together. Repeat the layers twice more and end with a layer of bread. Beat the eggs, milk, sugar, and rose-water together and pour them into the dish. Let the pudding stand for 15 minutes for the bread to soak up the liquid. Bake the pudding for 1¼ hours. While it is cooking, make the sauce. Put the wine (or sherry), sugar, and nutmeg in a saucepan. Set it on low heat and stir until the sugar has dissolved. Simmer for 5 minutes. Pour it into a jug and serve hot. If possible, take the pudding to the table in the dish.

Serves about 25.

꿈

Bread pudding made just a little different by the fragrant flavor of rose-water. The sauce makes it into a truly special dish.

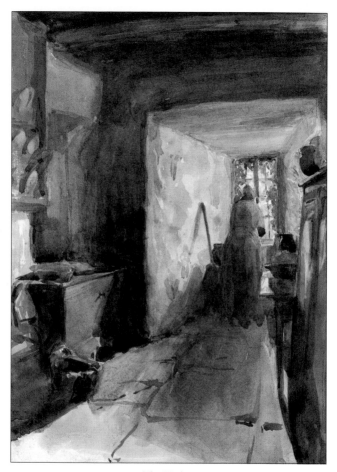

*The Kitchen*
Drawing, watercolor and pencil on paper, 31.5 x 22.3 cm (12⁷⁄₁₆ x 8¹³⁄₁₆ in.)
Freer Gallery of Art, Smithsonian Institution

**WHISTLER'S MOTHER'S COOK BOOK**

# Pastry

· · · · · · · · · · · · · ·

## Paste

*Rub fresh lard into your Flour    work it up quick with cold water*
*roll it out three times with Butter    spread over it about ¾ of a pound*
*to a pound of Flour    strew dry Flour*
*do not work it any after rolling in the Butter.*

**6 CUPS FLOUR**          **½ CUP LARD**              **1 ½ CUPS BUTTER,**
                                                                                **SOFTENED**

**1 TEASPOON SALT**    **½ CUP ICED WATER**

**S**ift 4 cups of flour and salt into a bowl. Rub in the lard
until it resembles bread crumbs. Make it into dough with
the iced water. Put the dough on a floured board and roll it
out flat into a rectangular shape. Spread ½ cup of the butter on
two-thirds of the surface and scatter over it one-third of the
remaining flour. Fold the dough into three, give it a half turn
on your floured board, and roll it out again in the other direc-
tion. Fold it again. Wrap it in greaseproof paper and chill for
20 minutes. Repeat the process twice more. After the last chill-

ing, the pastry can be used right away or can be kept in the refrigerator for up to 3 days. It can also be frozen.

≈

A light, flaky pastry, suitable for making covered pies such as Common Apple Pie (opposite) and Mince Pies (page 90).

# APPLE PIE

*stew your apples strain them, add a lump of Butter, eggs according to the quantity, three to a pint, sugar, powdered orange peel a few spoonsful of cream. bake open in a paste.*

| | | |
|---|---|---|
| SHORTCRUST PASTRY MADE WITH 2 CUPS FLOUR | 2 TABLESPOONS WATER | ¼ CUP SUGAR |
| | 2 TABLESPOONS BUTTER | 2 TABLESPOONS HEAVY OR DOUBLE CREAM |
| 5 MEDIUM COOKING APPLES | 3 EGGS | 1 ORANGE RIND, GRATED |

*Oven at 375°F/190°C/Reg 5*

Make the pastry. Peel, core, and chop the apples. Put them in a saucepan with the water. Cover and set on low heat for 15 minutes. Rub the apples through a sieve and beat in the butter. Beat the eggs with the sugar and cream and mix them into the apples. Add the orange rind. Divide the pastry in half. Roll it out and line two 8-inch-diameter flan dishes. Pour in the apple mixture and bake the pies for 45 minutes, until they are set and golden on top. Serve hot or cold.

Serves 16.

≈

Open flans with a creamy apple filling, sharply flavored with orange.

# COMMON APPLE PIE

*Put a thin crust at the Bottom of your plates. slice your apples thin.*
*put a layer of Apples, then coarse sugar and powdered cinamon and a*
*little allspice in layers untill your plates are filled   then pour over a*
*little rose-water or quince syrup or any other syrup you have to spare.*
*cover them with a paste.*

PASTE (PAGE 87)
MADE WITH 1½ CUPS
FLOUR

4 MEDIUM COOKING
APPLES

½ CUP DEMERARA OR
RAW SUGAR

3 TEASPOONS GROUND
CINNAMON

3 TEASPOONS GROUND
ALLSPICE

1 TABLESPOON QUINCE
OR APPLE JELLY OR 2
TABLESPOONS ROSE-
WATER

BEATEN EGG OR MILK
FOR GLAZE

*Oven at 425°F/220°C/Reg 7*

Line an 8-inch-diameter pie plate with two-thirds of the
paste. Peel, core, and thinly slice the apples. Put one-
third of them into the bottom of the pie and sprinkle them
with one-third of the sugar and spices. Do this twice more and
spoon the quince or apple jelly or the rose-water on top.
Cover the pie with the remaining paste. Prick all over with a
fork. Brush the top with beaten egg or milk. Bake for 40 min-
utes. Serve hot with Soft Custard (page 93) or with cream.

Serves 8.

❧

A juicy apple pie with a flaky crust, highly spiced and delicious
for any occasion.

# MINCE PIES

*1 part tender beef   one of fresh suet or butter   one of apples
one of Fruit, consisting of raisins, stoned and chaped, currants and
citron. wet it with equal parts of Brandy   sweet wine, and sweet
cyder, cloves   nutmeg, cinamon, allspice, dried orange peel,
the juice of a fresh lemon.*

4 OUNCES LEAN STEWING STEAK, SUCH AS CHUCK OR SKIRT

4 OUNCES FRESH BEEF SUET <u>OR</u> ½ CUP BUTTER

1 LARGE COOKING APPLE

⅓ CUP RAISINS

⅓ CUP CURRANTS

⅓ CUP CHOPPED CANDIED CITRON PEEL OR ANY OTHER CANDIED PEEL

½ TEASPOON CLOVES, GROUND

½ NUTMEG, GRATED

½ TEASPOON GROUND ALLSPICE

1 ORANGE RIND, GRATED

JUICE OF 1 LEMON

2 TABLESPOONS BRANDY

2 TABLESPOONS SWEET WHITE WINE

2 TABLESPOONS SWEET CIDER

PASTE (PAGE 87) MADE WITH 6 CUPS FLOUR

BEATEN EGG FOR GLAZE

*Oven at 425°F/220°C/Reg 7*

Chop the beef very fine and grate the suet. Peel, core, and finely chop the apple. Chop the raisins. Put all these into a bowl with the currants, candied peel, spices, and orange rind. If you are using butter instead of suet, melt it, and mix it in. Mix in the lemon juice, brandy, wine, and cider. Roll out the pastry and stamp out 72 rounds with a 3-inch cutter. Use them to line tartlet tins. Put a small spoonful of mincemeat into each one and cover it with a 2½-inch round. Brush the tops with beaten egg. Prick them with a fork. Bake the pies for 30 minutes. Serve hot.

Rich, spicy, and juicy mincemeat in light, flaky pastry. The pies are definitely a sweet and not a savory, despite the beef.

From medieval times until the nineteenth century, mince pies contained a mixture of meat and fruit. The meats that were used varied—poultry, game, beef, mutton, or a mixture of these. Fruit was added in the proportion of about three-quarters meat to one-quarter fruit. The spices commonly added were cinnamon, nutmeg, and cloves. The pastry was often substantial enough to enable the pies to keep for considerable periods during the winter months, when fresh meat was scarce. In Victorian times the proportion of meat became less and less, until now our mincemeat contains only a little shredded suet with large amounts of fruit and spices.

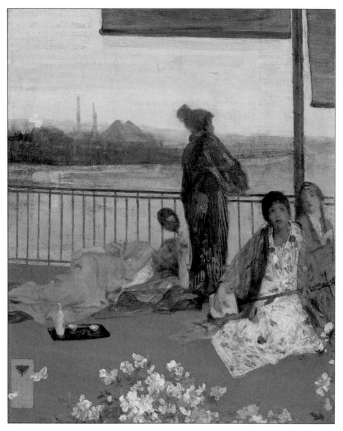

*Variations in Flesh Color and Green: The Balcony,* 1864
Painting, oil on wood panel, 61.4 x 48.8 cm (24 3/16 x 19 1/4 in.)
Freer Gallery of Art, Smithsonian Institution

# SWEETS

. . . . . . . . . . . . . .

## SOFT CUSTARD

*Boil 1 qt milk   pour it on the yolks of 8 eggs well beat with sugar to*
*your taste   put it over the fire, stirring all the time till thick enough.*

**8 EGG YOLKS**                **½ CUP SUGAR**                **5 CUPS MILK**

**W**hisk the egg yolks with the sugar. Bring the milk to the boil and take the pan from the heat. Beat 8 tablespoonsful hot milk into the egg yolks. Stir them back into the saucepan. Put the pan back on the stove on very low heat. Keep stirring until the mixture thickens, without letting it come to the boil.

Serves 10.

≈

A sweet, creamy custard that is delicious with Common Apple Pie (page 89).

_Lemon Cream._

Take four lemons, pare
them very thin put them
into half a pint of water
let them stand 12 hours
then squeeze the juice of
four lemons to the peels
& strain it, and put half
a pint more water, then
take the whites of 8 eggs
& the yolks of 3 beat them
well with 4 spoonsfull of
rose water. Put the water
and the juice of the lemons
to the eggs, sweeten in with
loaf sugar to your taste
strain it, set it over a slow
fire and stir it till it is
thick, then take it off cool
it and put it in glasses.

Anna Whistler's recipe for Lemon Cream
Photograph courtesy Glasgow University Library

# LEMON CREAM

*Take four lemons   peal them very thin   put them into half a pint of*
*water   let them stand 12 hours   then squeeze the juice of four lemons*
*to the peals   strain it, and put half a pint more water, then take the*
*whites of 8 eggs & the yolks of 3   beat them well with 4 spoonsfull of*
*rose water. Put the water and the juice of the lemons to the eggs,*
*sweeten it with loaf sugar to your taste   strain it, boil it over a slow fire*
*and stir it till it is thick. Then take it off cool it and put it in glasses.*

| | | |
|---|---|---|
| **4 LEMONS** | **1¼ CUPS COLD WATER** | **4 TABLESPOONS ROSE-WATER** |
| **1¼ CUPS BOILING WATER** | **3 EGGS** | |
| | **5 EGG WHITES** | **1 CUP SUGAR** |

Thinly pare the rinds from the lemons and put them into a
bowl. Pour the boiling water over the rinds and let stand
for 12 hours. Strain the liquid into a bowl and discard the
peels. Squeeze the juice from the lemons and strain it into the
liquid. Add the cold water. Whip the eggs and whites with the
rose-water until they are light and frothy. Fold in the lemon
water, juice, and sugar and pour the mixture into a saucepan.
Set it on low heat and stir it for about 10 minutes, until the
mixture becomes thick. Take the pan from the heat and let the
mixture cool. Pour it into glasses and put it in a cool place or
in the refrigerator to set.

Serves 16.

≈

A soft, creamy yellow sweet that does not set completely but just
holds together in peaks. It has a sharp, refreshing flavor like
lemon curd and is the perfect sweet to follow a rich meat course.

# BLANCMANGE

*2 quarts cream   1 ounce and half isinglass, beat it fine and*
*stir into the cream   let it boil quietly till dissolved then sweeten to*
*your taste   add as much rose water as you please then cool*
*pour it in your moulds*

| | | |
|---|---|---|
| 1½ TABLESPOONS POWDERED ISINGLASS | 10 CUPS HEAVY OR DOUBLE CREAM | ½ CUP ROSE-WATER  ½ CUP SUGAR |

**S**oak the isinglass in the cream until it softens. Put the cream and isinglass into a saucepan and melt the isinglass gently on low heat, stirring occasionally. Take the pan off the heat, cover, and leave it for an hour to cool. Rub the mixture through a fine sieve into a clean saucepan. Put it on low heat for about 15 minutes, stirring occasionally, until the isinglass has dissolved. Stir in the rose-water and sugar thoroughly. Pour into individual glasses or into a jelly mold to set.

Serves about 24.

~

A sweet, gently scented dessert, very rich and creamy. It is delicious on its own, sprinkled with freshly grated nutmeg. It can also be set in a large bowl and spooned on top of a fresh fruit salad.

Note: Isinglass is a comparatively pure form of gelatin. It is not readily available now; 4 tablespoonsful of unflavored gelatin can be substituted for the isinglass to produce a similar effect. In this case, there is no need to heat the cream a second time.

# FLOATING ISLAND

*Take a cup of currant jelly    beat the whites of 3 eggs to a froth*
*add a spoonful of rose water    then put it in a dish of cream on which*
*it will float, sweeten your milk or cream to your taste*

| 2½ CUPS HEAVY OR DOUBLE CREAM | 3 EGG WHITES | 1 TABLESPOON ROSE-WATER |
|---|---|---|
| 1 TABLESPOON SUGAR | 1 CUP RED CURRANT JELLY | |

**W**hip the cream with the sugar until it stands up in peaks. Put it in a large serving dish and smooth the top. Stiffly whip the egg whites and whisk in the red currant jelly 1 tablespoonful at a time. Beat in the rose-water. Spoon the mixture in eight peaks on top of the cream. Serve as soon as possible after making or the peaks will gradually subside.

Serves 8.

～

Light, fluffy, pink islands floating on a creamy sea. A delicate combination of flavors that tastes as good as it looks.

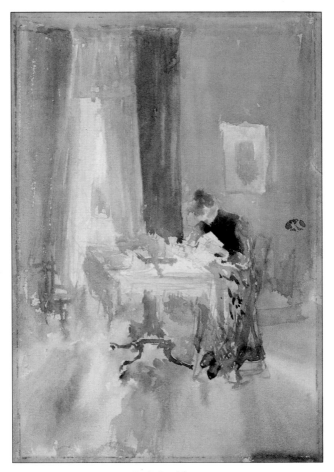

*Note in Opal: Breakfast,* early 1880s
Painting, watercolor on paper, 25.2 x 17.6 cm (9¹⁵⁄₁₆ x 6¹⁵⁄₁₆ in.)
Freer Gallery of Art, Smithsonian Institution

# CAKES

· · · · · · · · · · · ·

## RICH CAKES

## LEMON CAKE

*2 cups of Butter   3 of sugar   four of Flour   two lemons
squeeze the juice into a small piece of pearl ash—8 eggs.—*

| | | |
|---|---|---|
| **4 CUPS FLOUR** | **3 CUPS SUGAR** | **2 TEASPOONS BAKING POWDER** |
| **2 CUPS BUTTER** | **8 EGGS, BEATEN** | **JUICE OF 2 LEMONS** |

*Oven at 325°F/160°C/Reg 3
Prepare two 8-inch-diameter cake tins.*

**S**ift the flour. Cream the butter and beat in the sugar until it is light and fluffy. Beat the eggs into the butter mixture alternately with the flour. Dissolve the baking powder in the lemon juice and add it to the rest. Mix everything together thoroughly. Divide the mixture between the two tins and bake the cakes for 30 minutes. Lower the heat to 300°F/150°C/Reg

2 and cover the tops of the cakes with foil or greaseproof paper. Continue baking for about 1 hour, until an inserted skewer comes out clean. Cool the cakes for 30 minutes in the tins and turn them onto wire racks to cool completely.

Golden, buttery cakes with a sweet lemon flavor. See page 55 for a note on pearl ash.

# QUEENS CAKE

*One pound of flour, one of sugar, ¾ of butter, one gill cream, one gill of Brandy, 5 eggs—a nutmeg, and a pound of fruit.—*

| | | |
|---|---|---|
| 1 CUP CURRANTS | 1 NUTMEG, GRATED | 5 EGGS, BEATEN |
| 1 ½ CUPS RAISINS | 1 ½ CUPS BUTTER | ⅝ CUP LIGHT OR SINGLE CREAM |
| 4 CUPS FLOUR | 2 CUPS SUGAR | ⅝ CUP BRANDY |

*Oven at 340°F/170°C/Reg 3*
*Prepare an 8-inch-diameter cake tin.*

**M**ix the fruit with ½ cup of the flour. Sift the remaining flour into a bowl with the nutmeg. Cream the butter and beat in the sugar until the mixture is light and fluffy. Beat in the eggs, cream, and brandy alternately with the flour. Fold in the currants and raisins. Put the mixture into the prepared tin and bake it for 1 hour, covering the top with greaseproof paper or foil after the first 30 minutes. Lower the heat to 300°F/150°C/Reg 2 and continue baking for a further 1½ hours or until an inserted skewer comes out clean. Cool the cake in the tin for 30 minutes

and turn it onto a wire rack to cool completely.

~~~

A rich, moist, fruity cake, strongly flavored with brandy and spices and really fit for a queen.

COMPOSITION CAKE

1 pound flour, ¾ lb of Sugar, ½ pound butter, 4 eggs,
1 tea spoonfull of pearl ash, tea cup of milk, wine glass brandy
fruit and spice as you please.

1 CUP RAISINS	2 TEASPOONS GROUND CINNAMON	1½ CUPS SUGAR
1 CUP CURRANTS	¼ NUTMEG, GRATED	4 EGGS, BEATEN
4 CUPS FLOUR	1 CUP BUTTER	¾ CUP MILK
1 TEASPOON BAKING POWDER		½ CUP BRANDY

Oven at 340°F/170°C/Reg 3
Prepare an 8-inch-diameter cake tin.

Mix the fruit with ½ cup of the flour. Sift the remaining flour with the baking powder and spices. Cream the butter in a large mixing bowl and beat in the sugar until the mixture is light and fluffy. Beat in the eggs and then the flour alternately with the milk and brandy. Fold in the fruit. Pour the mixture into the prepared tin and put it in the oven for 1½ hours, covering the top with greaseproof paper or foil after the first 30 minutes. Turn the heat down to 300°F/150°C/Reg 2. Remove the paper or foil and continue baking for about an hour, until an inserted skewer comes out clean. Cool the cake

in the tin for 30 minutes and turn it onto a wire rack to cool completely.

❧

A good fruity cake, not so moist as the previous recipe, with a spicy flavor. It is rather like fruit loaf in texture. See page 55 for a note on pearl ash.

CUP CAKE

5 tea cups of flour, one of butter, two of sugar two eggs,
1 tea spoonfull of pearl ash 4 spoonsfull of milk, some cinnamon—

4 CUPS FLOUR	3 TEASPOONS CINNAMON	1 CUP MILK
1 TEASPOON BAKING POWDER	2 EGGS	¾ CUP BUTTER
		1½ CUPS SUGAR

Oven at 340°F/170°C/Reg 3
Prepare an 8-inch-diameter cake tin.

Sift the flour with the baking powder and cinnamon. Whisk the eggs with the milk. Cream the butter in a bowl and beat in the sugar until the mixture is light and fluffy. Beat in the flour alternately with the eggs and milk. Put the mixture into the prepared tin and bake the cake for 1½ hours, covering the top with foil or greaseproof paper after 30 minutes. Remove the foil or paper and continue baking for about 30 minutes, until an inserted skewer comes out clean. Allow the cake to cool in the tin for 30 minutes and then turn it onto a wire rack to cool completely.

❧

A light brown cake, a little like a Madeira cake. The cinnamon flavor is delicious. See page 55 for a note on pearl ash.

CIDER CAKE

2 lbs flour 1 lb sugar, 1 lb Raisins, 1 pint Cider,
2 teaspoons full of pearlash, spices or other flavor to your taste

8 CUPS FLOUR	**2 CUPS SUGAR**	**2½ CUPS STILL, DRY CIDER <u>OR</u> DRY WHITE WINE <u>OR</u> HALF WINE AND HALF APPLE JUICE**
2 TEASPOONS BAKING POWDER	**2⅔ CUPS RAISINS**	
1 NUTMEG, GRATED		**BUTTER FOR GREASING**

Oven at 350°F/180°C/Reg 4

Sift the flour into a bowl with the baking powder and grated nutmeg. Mix in the sugar and raisins and make a well in the center. Pour in the cider and mix everything to a smooth dough. Press it into two buttered 2-pound loaf tins. Bake the cakes for 1 hour and immediately turn them onto wire racks to cool.

❧

A moist and spicy cake that should be served like a fruit loaf, with or without butter to taste. See page 55 for a note on pearl ash.

PINT-CAKE I

1 & ¾ lb Butter, same of sugar same of flour 14 eggs
4 lb currants 1½ lbs Raisins 1½ lb citron ½ oz cloves
same of cinnamon same of nutmeg,
mace quarter of an ounce, rosewater ½ pint Brandy

10⅔ CUPS CURRANTS	**3½ CUPS BUTTER**	**1 TABLESPOON GROUND MACE**
4 CUPS RAISINS	**3½ CUPS SUGAR**	**1 NUTMEG, GRATED**
4 CUPS CANDIED CITRON PEEL OR A MIXTURE OF CANDIED PEELS	**2 TABLESPOONS GROUND CLOVES**	**14 EGGS, BEATEN**
	1 TABLESPOON GROUND CINNAMON	**2 TABLESPOONS ROSE-WATER**
7 CUPS FLOUR		**1¼ CUPS BRANDY**

Oven at 325°F/160°C/Reg 3
Prepare three 8-inch-diameter cake tins.

Mix the fruit and candied peel with 1 cup of the flour. Cream the butter in a large mixing bowl and beat in the sugar until the mixture is light and fluffy. Sift the remaining flour with the spices and beat it into the butter and sugar alternately with the eggs. Beat in the rose-water and brandy. Fold in the fruit and candied peel. Divide the mixture between the prepared tins. Bake the cakes for 1 hour, covering them with foil or greaseproof paper after 30 minutes. Turn the heat down to 300°F/150°C/Reg 2 and continue baking for 1½ hours or until an inserted skewer comes out clean. Cool the cakes for 30 minutes in the tins and turn them onto wire racks to cool completely.

≈

Moist but light-textured cakes, very spicy and packed full of fruit.

SPONGE CAKES

DIET BREAD

to every egg put a spoonful of powdered sugar the same of flour and a little peach water. beat it well twenty or thirty minutes. bake it quick.

4 EGGS

4 TABLESPOONS SUGAR

4 TABLESPOONS FLOUR

1 TABLESPOON PEACH WATER OR ROSE-WATER

Oven at 400°F/200°C/Reg 6

Put the eggs and sugar into a bowl and whisk them together over warm water until they are really thick. Beat in the peach water or rose-water and flour. Butter a 1-pound loaf tin. Pour in the mixture and bake it for 30 minutes. Turn the cake onto a wire rack to cool.

～

This "bread" is a light, fragrant sponge cake that can be eaten plain or with a fruit preserve. It rises high in the oven but shrinks and shrivels slightly as it cools. Diet bread in Mrs. Whistler's day was probably for convalescents.

SPONGE CAKE

8 eggs, the weight of them in sugar, the weight of 4 in flour, nutmeg to your taste—Beat the yolks & sugar together, then add the whites & flour,—

8 EGGS, SEPARATED	2 CUPS FLOUR	½ NUTMEG, GRATED
2 CUPS SUGAR		

Oven at 375°F/190°C/Reg 5

Beat the egg yolks with the sugar until they are creamy. Sift the flour with the nutmeg and beat it into the yolks. Stiffly whip the egg whites and fold them into the yolks and flour. Divide the mixture between four 7-inch-diameter buttered sandwich tins and bake the cakes for about 17 minutes. Cool them in the tins for 10 minutes and turn them onto wire racks to cool.

~

Light sponge cakes that can be sandwiched together with a jam or fruit filling and topped with icing, sugar, or whipped cream.

CAKES MADE WITH YEAST

RAISED POUND CAKE

Two pounds flour—pound of sugar three quarters butter
pint of milk pint of emptins pint of wine—9 eggs—a nutmeg—
some mace—one pound currants half pound of raisins,
mix it in the morning and put it in the pans you intend to bake it in.
keep in a gentle warmth till next morning, and then bake it—

2 PACKETS BAKER'S YEAST	1⅓ CUPS RAISINS	1½ CUPS BUTTER
2½ CUPS WARM MILK	8 CUPS FLOUR	9 EGGS, BEATEN
2 CUPS SUGAR	1 NUTMEG, GRATED	2½ CUPS SWEET WHITE WINE
2⅔ CUPS CURRANTS	1 TEASPOON GROUND MACE	

Oven at 400°F/200°C/Reg 6
Prepare two 8-inch-square cake tins.

Crumble the yeast into a bowl and cream it with the milk and 2 teaspoonsful of the sugar. Put the mixture into a warm place for 10–15 minutes, until it begins to froth. Mix the fruit with 1 cup of the flour. Sift the remaining flour into a bowl with the spices. Beat the butter until it is soft and then beat in the remaining sugar until the mixture becomes light and fluffy. Beat in the flour alternately with the eggs, wine, and yeast mixture. Fold in the fruit. Divide the mixture between the prepared tins. Cover them with a clean, damp cloth and put them into a warm place for 2 hours to rise, until the mixture comes to the tops of the tins. Bake the cakes for 15 minutes. Lower the heat to 325°F/160°C/Reg 3 and cover the cakes with foil or greaseproof paper. Continue baking for a further 1½ hours or until an inserted skewer comes out clean. Cool the cakes in the tins for 30 minutes and turn them onto wire racks to cool.

≈

A rich and spicy fruit cake with a light texture. With modern yeast, the rising time will be less than that needed in Mrs. Whistler's day. See page 54 for a note on emptins, under "Yeast."

PINT CAKE II

A pint of milk, a pt of emptins, a pint of sugar, a pint of butter, 3 eggs, spice as you like and about as stiff as pound cake—

1 PACKET BAKER'S YEAST	2½ CUPS WARM MILK	1 NUTMEG, GRATED
2½ CUPS SUGAR	4 CUPS FLOUR	3 EGGS, BEATEN
2½ CUPS BUTTER	1 TABLESPOON GROUND CINNAMON	

Oven at 350°F/180°C/Reg 4
Prepare two 8-inch cake tins.

Crumble the yeast into a bowl and cream it with 1 teaspoonful of the sugar. Cut the butter into small pieces. Stir it into the milk and let it melt. Stir the mixture into the yeast and put it in a warm place for 10–15 minutes, until it is frothy. Sift the flour and spices into a bowl and mix in the remaining sugar. Make a well in the center and pour in the yeast mixture and eggs. Beat everything together well. Divide the mixture between the two prepared tins, cover with a clean, damp cloth, and put the tins in a warm place for 2 hours until the mixture has risen and looks light and bubbly. Bake the cakes for 15 minutes and cover them with foil or greaseproof paper. Continue baking for about 1 hour, until an inserted skewer comes out clean. Cool the cakes in the tins for 30 minutes and turn them onto wire racks to cool completely.

≈

Spicy cakes with a nice moist texture. See page 54 for a note on emptins, under "Yeast."

GOOD FRUIT CAKE

1 lb Flour. 1¼ sugar the same of Butter. 1 doz. eggs. 1 lb Raisins stoned and chaped, 1 of currants 2 oz citron a glass of Brandy, one of wine a gill of sweet cream, the same of yeast, one nutmeg.

20 cloves, cinamon and dried orange peel, beat the butter and cream
untill allmost liquid add the flour beat the eggs separate,
put the yolks to the sugar, and add the whites
after every ingredient is put together.

1 PACKET BAKER'S YEAST	2⅔ CUPS CURRANTS	12 EGGS, SEPARATED
2½ CUPS SUGAR	4 CUPS FLOUR	2½ CUPS BUTTER
⅝ CUP WARM MILK	1 NUTMEG, GRATED	⅝ CUP LIGHT OR SINGLE CREAM
4 TABLESPOONS CHOPPED CANDIED CITRON PEEL OR A MIXTURE OF CANDIED PEELS	20 CLOVES, GROUND	½ CUP BRANDY
	1 TEASPOON GROUND CINNAMON	½ CUP SWEET WHITE WINE OR SHERRY
2⅔ CUPS RAISINS	RIND OF 1 ORANGE, GRATED	

Oven at 400°F/200°C/Reg 6
Prepare two 8-inch cake tins.

Crumble the yeast into a bowl and cream it with 1 tea-spoonful of the sugar and the milk. Put it into a warm place for 10–15 minutes, until it is frothy. Mix the candied peel and fruit with 1 cup of the flour. Sift the remaining flour with the spices and add the orange rind. Whisk the egg yolks with the remaining sugar until they are creamy. Beat the butter until it is soft, and beat in the cream. Beat the flour into the butter alternately with the egg yolks and sugar, brandy, and wine. Cover the mixture with a clean, damp cloth and leave it in a warm place for 1 hour, until it has risen. Fold in the fruit. Last of all, whip the egg whites until they are stiff and fold them into the mixture. Divide the mixture between the prepared tins and leave them on top of the heated stove for 30 minutes covered with a clean, damp cloth, until the mixture reaches

almost to the top of the tin and looks frothy. Bake the cakes for 30 minutes. Lower the heat to 350°F/180°C/Reg 4 and continue baking for another hour or until an inserted skewer comes out clean. Cool the cakes in the tins for 30 minutes and turn them onto wire racks to cool completely.

A moist and very rich cake with a light texture and a subtle blend of flavors.

DOUGH CAKE

7 lb dough made with milk & yeast after it is risen add 3 lb Butter 4 lb sugar 16 eggs & 4 lb Raisins.—

2 PACKETS BAKER'S YEAST	**10⅔ CUPS RAISINS**	**6 CUPS BUTTER**
2 TEASPOONS SUGAR	**16 CUPS FLOUR**	**8 CUPS SUGAR**
5 CUPS WARM MILK	**2 TABLESPOONS SALT**	**16 EGGS, BEATEN**

Oven at 400°F/200°C/Reg 6

Cream the yeast with the sugar and milk and leave in a warm place for 10–15 minutes, until it is frothy. Mix the raisins with 1 cup of the flour. Sift the remaining flour into a bowl with the salt. Make a well in the center and pour in the yeast mixture. Mix everything to a dough, turn it onto a floured board and knead it well. Return the dough to the bowl and make a crosscut in the top. Cover it with a clean, damp cloth and leave it in a warm place for 1 hour to rise. Warm and soften the butter and knead it into the dough.

Break up the dough and beat in the sugar and eggs. Fold in the raisins. Lightly butter two 8 x 12-inch cake tins and divide the mixture between them. Put the cakes, covered with a damp cloth, on top of the heated stove for 20 minutes to proof. Bake the cakes for 1 hour, covering the tops with greaseproof paper or foil after the first 30 minutes.

～

A good, juicy fruit cake that keeps well.

SMALL CAKES

Mackroons

1½ lb Almonds lay them in water all night
blanch and dry them well beat them fine in a mortar. ½ lb sugar
the whites of 2 eggs beaten to a froth stir in the sugar,
add the almonds drop them on buttered paper sift sugar over them.

6 CUPS ALMONDS 1¼ CUPS SUGAR 2 EGG WHITES

Oven at 350°F/180°C/Reg 4

Lay buttered greaseproof paper on baking sheets. Put the almonds in a saucepan and cover them with cold water. Bring them gently to the boil and immediately take them from the heat and drain them. Squeeze them from their skins. Put them into a blender and grind them very fine. Put the ground almonds into a bowl and mix in 1 cup of the sugar. Stiffly whip the egg whites and fold them into the almonds. Beat well so the mixture sticks together. Shape the mixture firmly into

round cakes 1½ inches in diameter and ½ inch thick. Lay them on the buttered paper and sift the rest of the sugar over them. Bake them for 20 minutes, at which time they will be set and only just beginning to brown. Lift them off the baking sheets all together, still on the paper. Put them onto wire racks to cool.

Makes 36–40.

❧

Delicate macaroons, firm on the outside and soft and chewy in the middle, with a good natural almond flavor.

Note: There is no need to soak the almonds if you are using a blender or nut mill. This was necessary only to soften them sufficiently to make the job of grinding with a pestle and mortar easier. Store-bought ground almonds are generally too dry; if you use them, the mixture will not stick together as it should and the flavor will be very much less noticeable.

SUGAR CAKE

4 cups Sugar, 2 cups Butter, 4 Eggs,
and as much flour as will make them stiff enough to roll.

4 CUPS SUGAR　　　　**4 EGGS, BEATEN**　　　　**5 CUPS FLOUR**
2 CUPS BUTTER

Oven at 375°F/190°C/Reg 5

Beat the sugar and butter together until creamy. Beat in the eggs alternately with the flour to make a light dough. Roll it out on a floured board and cut it into shapes with a bis-

cuit cutter. Put the shapes on greased baking sheets and bake for 15 minutes. Cool them immediately on a wire rack.

Makes 100.

≈

Sweet, crispy cookies.

GAMBLES I

1 lb of Butter, one of sugar 4 eggs rosewater.
Flour sufficient to stiffen them. roll them in powdered sugar

BUTTER AND SUGAR FOR TINS AND DREDGING	2 CUPS SUGAR	2 TABLESPOONS ROSE-WATER
	4 EGGS	6 CUPS FLOUR
2 CUPS BUTTER		

Oven at 355°F/180°C/Reg 4

Butter some baking tins and dredge them with sugar. Cream the butter in a bowl and beat in the sugar until it is light and fluffy. Whisk the eggs with the rose-water and beat them into the butter alternately with the flour. Shape the mixture into small rounds using two round-bladed knives. Roll them in sugar. Place them well apart on the baking sheets. Bake the cakes for 20 minutes and lift them onto wire racks to cool.

Makes about 48.

≈

Light sponge cakes with a crisp, sugary crust. The rose-water gives them a fragrant taste.

GAMBLES II

1 lb sugar 1½ lb of Flour 1¾ lb of butter, 4 eggs
seeds and rosewater to your taste, Roll the whole in sugar.

BUTTER AND SUGAR FOR TINS AND DREDGING	1 TABLESPOON CARAWAY SEEDS	4 EGGS
6 CUPS FLOUR	3½ CUPS BUTTER	2 TABLESPOONS ROSE-WATER
	2 CUPS SUGAR	

Oven at 355°F/180°C/Reg 4

Butter some bun tins 2½ inches across and 1 inch deep and dredge them with sugar. Sift the flour and mix in the caraway seeds. Cream the butter in a bowl and beat in the sugar until it is light and fluffy. Whisk the eggs with the rosewater and beat it into the butter alternately with the flour. Put spoonfuls of the mixture into the prepared tins and dredge the tops with sugar. Bake the cakes for 20 minutes and lift them onto wire racks to cool.

Makes about 30 buns.

❧

Sweet sponge cakes with sugary tops, slightly richer than the previous Gambles, with the added pungent flavor of caraway seeds.

Note: Although the instruction "roll them in sugar" may be applied to these cakes as with the previous ones, they are best baked in the bun tins, as they are richer and more likely to spread.

GINGERBREADS

· · · · · · · · · · · · ·

GINGERBREAD

6 eggs a pound of sugar a pint of Molasses made luke warm,
with a pound of butter melted; ginger to your taste
add flour untill the mixture is a stiff batter and three teaspoons of
dissolved pearlash, and ½ pint of milk or Buttermilk.

8 CUPS FLOUR	**4 TEASPOONS BAKING POWDER**	**2 CUPS SUGAR**
4 TEASPOONS GROUND GINGER	**2½ CUPS MOLASSES**	**6 EGGS**
	2 CUPS BUTTER	**1¼ CUPS MILK OR BUTTERMILK**

Oven at 340°F/170°C/Reg 3

Note: "Buttermilk" here did not mean the fermented kind similar to yoghurt that is sold today in cartons but the refreshing, slightly salty liquid left in the churn after butter was made. It would have made a slightly lighter cake than one made with milk.

Sift the flour into a bowl with the ginger and baking powder and make a well in the center. Put the molasses, butter, and sugar into a saucepan and melt them together on low heat. Whisk the eggs and milk or buttermilk together. Beat them into the flour alternately with the warm molasses mixture. Divide the mixture between two buttered 2-pound loaf tins and bake the cakes for 30 minutes. Turn the heat down to 300°F/150°C/Reg 2 and continue baking for 1 hour. Cool the cakes for 30 minutes in the tins and turn them onto wire racks to cool completely.

≈

A dark brown gingerbread loaf with a close texture, light, and with a good flavor. It can be served plain or spread with butter. See page 55 for a note on pearl ash.

HARD GINGERBREAD

a Pound and a half of Flour, half a pound of sugar, half pint Molasses, half pound Butter half ounce ginger little pearlash—

6 CUPS FLOUR	**1 TABLESPOON GROUND GINGER**	**1¼ CUPS MOLASSES**
2 TEASPOONS BAKING POWDER	**1 CUP SUGAR**	**1 CUP BUTTER**

Oven at 350°F/180°C/Reg 4

Sift the flour into a bowl with the baking powder and ginger. Make a well in the center. Put the sugar, molasses, and butter into a saucepan and melt them together on low heat. Pour them into the flour and mix everything

together well. Divide the mixture between two buttered 8 x 12-inch cake tins. Press it down and mark it into small square shapes or oblongs. Bake the gingerbread for 20 minutes and turn it onto wire racks to cool. Cut it into the shapes that you have previously scored, and store in an airtight tin.

❧

Dark, chewy gingerbread slices with a delicious flavor. See page 55 for a note on pearl ash.

GINGERBREAD FOR CHILDREN

3 Pint of Molasses & 2⅓ pint of cyder, 3 tea-spoonsfull dissolved pearlash 3 large spoons ginger 1¼ pounds of Butter.
mix to a stiff Batter—bake in a large loaf slowly

21 CUPS FLOUR	**3 TABLESPOONS GROUND GINGER**	**7½ CUPS MOLASSES**
3 TEASPOONS BAKING POWDER	**2½ CUPS BUTTER**	**6 CUPS STILL, DRY CIDER OR APPLE JUICE**

Oven at 300°F/160°C/Reg 2

Sift the flour into a bowl with the baking powder and ginger. Put the butter and molasses into a saucepan and melt them together on low heat. Make a well in the center of the flour and pour in the melted ingredients and the cider. Beat everything well. Divide the mixture between three buttered 8 x 12-inch tins. Bake the cakes for 1 hour and turn them onto wire racks to cool.

❧

A close-textured, dark gingerbread to be sliced and eaten with

butter. The cider gives it an unusual spicy flavor. See page 55 for a note on pearl ash.

SUGAR GINGERBREAD

A pint bowl of sugar three quarters of a pound of butter, eight eggs, three large spoonsful ginger, flour so that you can roll it.—

12 CUPS FLOUR	**2½ CUPS SUGAR**	**8 EGGS, BEATEN**
1½ CUPS BUTTER	**3 TABLESPOONS GROUND GINGER**	

Oven at 340°F/170°C/Reg 3

Sift the flour into a bowl. Cut up the butter and rub it into the flour until the mixture resembles bread crumbs. Mix in the sugar and ginger and make a well in the center. Pour the eggs into the flour and beat everything together to make a stiff dough. Turn it onto a floured board and roll it out about ¼ inch thick. Stamp it into shapes with a biscuit cutter and lay them on greased baking sheets. Bake them for 25 minutes and lift them immediately onto wire racks to cool.

Makes about 120 biscuits.

Sweet ginger biscuits, golden in color. The recipe is just right for making gingerbread men.

Bread and Biscuits

· · · · · · · · · · · ·

Puffed

4 lb of Flour ¾ of Butter 1 lb of sugar, 1 pint of milk, 12 eggs,
1 pound of currants, 3 spoonsfull of yeast, 12 cloves, 1 nutmeg—

4 PACKETS BAKER'S YEAST	**1½ CUPS BUTTER**	**1 NUTMEG, GRATED**
2 CUPS SUGAR	**16 CUPS FLOUR**	**12 EGGS, BEATEN**
2½ CUPS WARM MILK	**12 CLOVES, GROUND**	**2⅔ CUPS CURRANTS**

Oven at 410°F/210°C/Reg 6–7

Cream the yeast with 1 teaspoonful of the sugar and the milk. Add the butter, cut into small pieces, and let it dissolve. Leave for 10–15 minutes in a warm place to froth. Sift the flour into a large bowl with the remaining sugar, cloves, and nutmeg and make a well in the center. Pour in the yeast mixture and beaten eggs and add the currants. Mix everything into a moist dough. Turn it onto a floured board and knead until it is smooth and elastic. Return it to the bowl, cover

with a clean, damp cloth, and put it into a warm place for about 2 hours, until it doubles in size. Knead the dough again and form it into 64 small, round buns. Put them on floured baking sheets, cover them with the cloth, and put them on top of the heated stove for 15 minutes to proof. Bake them for 20 minutes and put them onto wire racks to cool.

~

Soft, spicy buns, superb with butter alone and equally good toasted after a few days.

RUSKS

One tumbler milk, 1 teacup of yeast, 3 cups flour 3 eggs made into
batter overnight in the morning add a coffee bowl of sugar butter
the size of an egg flour sufficiently thick to mould,
then butter your dishes, fill them set them near the fire,
when light cover them full with white of egg & sugar.

1 PACKET BAKER'S YEAST	5 CUPS FLOUR	1 EGG WHITE
1 CUP WARM MILK	3 EGGS, BEATEN	1 TABLESPOON SUGAR
½ CUP SUGAR	¼ CUP BUTTER, MELTED	

Oven at 410°F/210°C/Reg 6–7

Cream the yeast with the milk and 1 teaspoonful of the sugar; leave the mixture in a warm place for 10–15 minutes, until it begins to froth. Sift 3 cups of the flour into a bowl. Make a well in the center and beat in the yeast mixture and eggs. Cover the batter with a clean, damp cloth and leave

it in a warm place for about 1 hour, until it has risen and the top is frothy. Butter 24 bun tins 2½ inches in diameter and 1 inch deep. Beat the remaining flour and sugar and melted butter into the batter and mix everything together well to make a moist dough. Put portions into the bun tins, cover them with a clean, damp cloth, and put them on top of the heated stove for 15 minutes. Brush the tops with egg white and sprinkle with sugar. Bake the rusks for 20 minutes. If you want them hot for breakfast, make the first batter overnight and leave it standing in a warm place. Add the rest the next morning.

≈

Small, semisweet golden buns, well risen and light as air, with a shiny, sugar-speckled top. In Mrs. Whistler's day, "rusk" usually meant a light bread containing eggs and sugar.

SPONGERUSK

2 cups sugar one yeast two milk beat the eggs & sugar together add the milk and emptins stir in flour as thick as pancake batter let it stand from night untill morning where it will keep warm. then rub half cup of butter into a little flour, put it in and make it as hard as soft biscuit, make it in small loaves put it in pans where it will have room to rise when sufficiently light bake it in a slow oven.

2 PACKETS BAKER'S YEAST	**2 CUPS SUGAR**	**3 EGGS, BEATEN**
2 CUPS WARM MILK	**10 CUPS FLOUR**	**½ CUP BUTTER**

Oven at 400°F/200°C/Reg 6

Cream the yeast with the milk and 1 teaspoonful of the sugar and put it in a warm place for 10–15 minutes, until it begins to froth. Sift 3 cups of the flour into a bowl. Make a well in the center. Whisk the eggs and remaining sugar together and beat them into the flour with the yeast mixture. Cover the batter with a clean, damp cloth and leave it in a warm place for 2 hours (or overnight), until the mixture rises about half as much again and looks frothy. Rub the butter into the remaining flour until the mixture resembles bread crumbs, then beat it into the batter to make a moist dough. Turn it onto a floured board and knead it until it is smooth. Divide the dough between six buttered 1-pound loaf tins, cover them with a clean, damp cloth, and put them on top of the heated stove for 20 minutes. Bake the loaves for 35 minutes and turn them onto wire racks to cool.

A slightly sweet tea bread that is good buttered. It is similar to the recipe for Rusks (page 120) but not quite so light in texture.

WHIGS

Take ½ pound butter half lb of sugar 1 pint milk, 6 eggs,
2 pounds flour & half pint emptins, make them in the morning
and they will be fit to bake at tea time.
Raise them in the pans you intend to bake them in—

2 PACKETS BAKER'S YEAST	**2½ CUPS WARM MILK**	**8 CUPS FLOUR**
1 CUP SUGAR	**1 CUP BUTTER**	**6 EGGS, BEATEN**

Oven at 410°F/210°C/Reg 6–7

Cream the yeast with 1 teaspoonful of the sugar and the milk. Put in a warm place for 10–15 minutes, until it begins to froth. Stir in the butter, cut into small pieces, and let it melt. Sift the flour into a bowl and add the remaining sugar. Make a well in the center and pour in the yeast mixture and beaten eggs. Mix everything to a moist dough. Turn it onto a floured board and knead it until it is smooth and elastic. Return the dough to the bowl. Cover it with a clean, damp cloth and leave it in a warm place for 1–2 hours, until doubled in size. Knead the dough again and form it into 32 small, round buns. Put them on a floured baking sheet, cover them with the cloth, and put them on top of the heated stove for 15 minutes to proof. Bake the whigs for 20 minutes and put them onto a wire rack to cool.

❧

Soft, golden-brown buns with a thin but crispy crust, to be eaten buttered for breakfast or for afternoon tea, with home-made jam. The recipe originally came from England. In the eighteenth century "whig" usually referred to a light, spiced bun (often with caraway seeds). The name seems to have originated as early as the fifteenth century, derived from the Teutonic word *weig*, meaning wedge-shaped. See page 54 for a note on emptins, under "Yeast."

BISCUITS

4 pounds flour, 10 oz butter 8 eggs 4 spoonsful emptins
mix it hard, heat the oven while mixing—

16 CUPS FLOUR **3 CUPS WARM WATER** **8 EGGS, BEATEN**

4 PACKETS BAKER'S **1¼ CUPS BUTTER**
YEAST

Oven at 410°F/210°C/Reg 6–7

Sift the flour into a bowl. Cream the yeast with the water. Melt the butter on low heat. Make a well in the center of the flour and pour in the yeast mixture, butter, and eggs. Mix everything into a dough. Turn it onto a floured board and knead it well. Roll it out to about ¼ inch thick and stamp it into 2½-inch rounds with a biscuit cutter. Lay the biscuits on floured baking sheets and prick them all over with a fork. Put them on top of the heated stove, cover them with a clean cloth, and leave them for 10 minutes. Bake for 15 minutes and place on wire racks to cool.

Makes about 150 biscuits.

≈

Plain, light biscuits that go well with cheese, soup, or savory dishes. It is not necessary to leave the yeast to froth. These little biscuits were always quickly made. See page 54 for a note on emptins, under "Yeast."

BUNNS

*One pound and half of flour (a quarter pound of which left to sift in
last) half pound butter cut up fine together, 4 eggs beat to a high froth
4 tea cups milk half wine glass Brandy stir it all together with a
knife and add ½ pound of sugar then sift in the quarter pound of
flour and when the lumps are all beaten
set them to rise in the pans they are baked in.*

6 CUPS FLOUR	**1 PACKET BAKER'S YEAST**	**3 CUPS WARM MILK**
1 CUP BUTTER		**4 EGGS**
	1 CUP SUGAR	**¼ CUP BRANDY**

Oven at 400°F/200°C/Reg 6

Sift 5 cups of the flour into a bowl. Cut in the butter with
a pastry cutter or rounded knife until the mixture is like
fine bread crumbs. Cream the yeast with 1 teaspoonful of the
sugar and all the warm milk. Leave in a warm place for 10–15
minutes, until it is frothy. Beat the eggs until they are creamy.
Make a well in the center of the flour and pour in the yeast
mixture, eggs, and brandy. Mix thoroughly with a rounded
knife. Beat in the remaining sugar. Scatter the remaining flour
over the top. Cover the bowl with a clean cloth and leave it for
about 5 minutes, until the yeast has bubbled up through the
flour. Mix everything to a stiff batter and beat well. Butter
some bun tins 2½ inches across and 1 inch deep. Fill them two-
thirds full with the mixture. Leave the buns in a warm place
until the mixture has risen to the tops of the molds. Bake for 25
minutes and turn them onto wire racks to cool.

Makes about 30 buns.

Sweet, light, golden buns, very good plain or with butter.

CARRAWAY BUNS

3 lbs Flour ¼ sugar ¾ butter
½ pint water with a teaspoonfull of pearlash dissolved in it
rub the butter into the flour, seeds as you like—

12 CUPS FLOUR	**4 TABLESPOONS CARAWAY SEEDS**	**2 TABLESPOONS BAKING POWDER**
1½ CUPS BUTTER	**½ CUP SUGAR**	**3¾ CUPS WARM WATER**

Oven at 400°F/200°C/Reg 6

Sift the flour into a bowl and rub in the butter until the mixture resembles fine bread crumbs. Add the caraway seeds and sugar. Make a well in the center. Dissolve the baking powder in the water and pour it into the flour. Mix everything into a dough, turn it onto a floured board, and knead it lightly. Either divide it between three buttered 2-pound loaf tins and bake the buns for 50 minutes or put small portions of the mixture on a floured baking sheet and bake them for 20 minutes. As soon as they are baked, put them onto wire racks to cool.

Makes about 50 small buns.

～

Plain, semisweet buns that are best served buttered. They go well with jam and marmalade and also with cheese.

See page 55 for a note on pearl ash. More water has been

added than suggested in the original recipe in order to give the dough a good texture.

MUFFINS

1 egg, pint and a half of milk, 2 oz Butter, 2 tablespoonful of yeast, a little pearlashes, and Flour enough to make a pretty stiff batter.—

1 PACKET BAKER'S YEAST	6 CUPS FLOUR	¼ CUP BUTTER, MELTED
1 TEASPOON SUGAR	1 TEASPOON BAKING POWDER	BUTTER FOR GREASING
3¾ CUPS WARM MILK	1 EGG, BEATEN	

Cream the yeast with the sugar and milk and put the mixture in a warm place for 10–15 minutes, until it begins to froth. Sift the flour into a bowl with the baking powder and make a well in the center. Beat in the yeast mixture, egg, and melted butter to make a stiff batter. Cover with a clean, damp cloth and leave in a warm place for about an hour, until it has doubled in size. Lightly grease a griddle and some muffin rings. Heat them on low heat. Half fill the muffin rings with batter and bake the muffins for 8 minutes on one side. Remove the rings, turn the muffins over, and bake the other side for 8 minutes. Continue in the same way until all the muffins are done. To eat, let them cool, toast them lightly on both sides, split them, and spread them with butter.

Makes about 40.

These muffins are good served dripping with butter and spread liberally with Quince or Peach Marmalade (see pages 135, 137). See page 55 for a note on pearl ash.

WAFFLES

1 lb flour ½ lb butter 1 quart milk 4 eggs a spoonful of yeast
boil the milk stir in the butter. put up all together very warm
let it stand to raise before baking.

5 CUPS MILK

1 CUP BUTTER

1 PACKET BAKER'S YEAST

1 TEASPOON SUGAR

4 CUPS FLOUR

4 EGGS, BEATEN

BUTTER FOR GREASING

Bring the milk to the boil. Stir in the butter and let it melt. Cool the milk and butter until they are lukewarm. Cream the yeast with the sugar and warm milk and put the mixture into a warm place for 10–15 minutes, until it is frothy. Sift the flour into a bowl and make a well in the center. Pour in the yeast mixture and eggs and beat everything into a smooth batter. Cover with a clean, damp cloth and leave in a warm place for 1 hour, until it doubles in size. Lightly grease a waffle iron and heat it on low heat. Pour in 2 tablespoonsful of the batter and cook the waffle for 3 to 4 minutes on each side, until it is golden brown and crisp. Continue in the same way until all the batter is used up. Serve with maple syrup or honey, with whipped cream if desired.

Makes about 40.

Crisp, airy waffles that are just right for breakfast.

CRELLA I

put to the proportions of one large spoonful of sugar
the same of melted butter to one egg. cinamon and nutmeg
to your taste stir in Flour but not very stiff.
roll them out to your fancy, and boil them in hot lard.

3 CUPS FLOUR	**1 TEASPOON GROUND CINNAMON**	**3 TABLESPOONS MELTED BUTTER**
3 TABLESPOONS SUGAR	**½ NUTMEG, GRATED**	**UP TO ½ CUP LARD FOR FRYING**
	3 EGGS, BEATEN	

Sift the flour into a bowl and mix in the sugar, cinnamon, and nutmeg. Make a well in the center and pour in the eggs and melted butter. Beat everything together to form a stiff dough. Turn it out on a floured board and roll it out to about ¼ inch thick. Stamp it into 2-inch rounds with a biscuit cutter. Heat 2 tablespoonsful of lard in a frying pan on moderate heat. Put in as many rounds as you can and fry them until they are golden brown on both sides. Remove them and keep them warm. Cook the rest in the same way, adding more lard when necessary. Serve the crella hot, sprinkled with sugar.

Makes about 30 cakes.

Sweet, spicy little biscuits that are ideal for a family dessert.

CRELLA II

Take six large spoonsfull of Sugar, 3 eggs, 3 spoons full of butter,
some nutmeg and made stiff with flour.

3 CUPS FLOUR	**½ NUTMEG, GRATED**	**3 TABLESPOONS MELTED BUTTER**
6 TABLESPOONS SUGAR	**3 EGGS, BEATEN**	**UP TO ½ CUP LARD FOR FRYING**

Make as for the previous recipe for crella and serve them in the same way with sugar.

❧

These crella are sweeter than those made in the previous recipe and not as spicy. They can be eaten straight out of the frying pan as a special treat.

PRESERVES

· · · · · · · · · · · · · ·

APPLE JELLY I

Take 20 large apples, pare and core them then put 1 quart of cold
water to them, put them over a steady fire where they will boil soft
When the apples are boiled to peices strain it through a flannel
to a pint of juice a lb of sugar boil it 45 minutes
the apples must not be stirred when boiling
the peel of a lemon or stick of cinnamon gives it a fine flavour.

20 LARGE COOKING APPLES	**1 LEMON RIND, THINLY PARED, OR 1 STICK CINNAMON**	**2 CUPS SUGAR TO 2½ CUPS STRAINED LIQUID**
5 CUPS COLD WATER		**2 ONE-POUND JARS, WARMED**

Peel, core, and slice the apples. Put them into a large
saucepan or preserving pan with the water and lemon
rind or cinnamon. Bring the apples to the boil and simmer for
1 hour, until they are very soft. Strain them through a jelly bag
and measure the liquid. Weigh out the required amount of

sugar. Return the liquid to the pan and bring it to the boil. Stir in the sugar until it has dissolved. Boil for about 15 minutes, until the setting point is reached. Skim the jelly and pour it into the warm jars. Cover the tops with waxed greaseproof paper. Cover completely when cool.

≈

A clear, delicate red apple jelly. The cinnamon gives it a particularly fragrant and distinctive flavor.

APPLE JELLY II

Take twenty good apples and boil them in two quarts of water till all the goodness is extracted, boil the skin of an orange or lemon with the apples, put the juice of them in the liquor when strained, to every pint of liquor add a lb of loaf sugar and boil it untill it is a Jelly.—

20 LARGE COOKING APPLES	**1 ORANGE OR 1 LEMON**	**3 ONE-POUND JARS, WARMED**
10 CUPS WATER	**2 CUPS SUGAR TO EVERY 2½ CUPS STRAINED LIQUID**	

Wash and roughly chop the apples, but do not peel or core them. Put them into a large saucepan or preserving pan with the water and the thinly pared rind of the orange or lemon. Bring them to the boil and simmer for about 1½ hours, until they are reduced to a pulp. Strain them through a jelly bag and measure the liquid. Return it to the pan and strain in the juice of the orange or lemon. Bring the liquid to the boil and stir in the required amount of sugar. Stir until it has dissolved. Boil rapidly for about 10 minutes, until the set-

ting point is reached. Skim the jelly and pour it into the warm jars. Put a round of waxed greaseproof paper on top. Cover completely when cold.

≈

A deep red jelly with a fresh flavor. It is particularly good with the subtle tang of orange.

Strip the currants from the stalks, put them in a jar set them in a pot of boiling water until the currants are broken strain it through flannel to every pint of juice a pound of sugar. boil and take the scum off. fifteen minutes will answer put it in glasses and set it in the sun.

4 POUNDS RED CURRANTS	2 CUPS SUGAR TO EVERY 2½ CUPS LIQUID	2 ONE-POUND JARS, WARMED

String the red currants and put them into a covered casserole or earthenware pot. Stand this in boiling water in a saucepan. Keep the water boiling gently for about ½ hour, until the red currants are soft and very juicy. Strain the liquid through a jelly bag and measure it. Put the liquid into a saucepan and bring it to the boil. Add the correct amount of sugar and stir until it has dissolved. Boil for about 10 minutes, until setting point is reached. Skim the jelly and pour it into the warm jars. Cover with rounds of waxed greaseproof paper. Cover completely when cold.

A very thick and deeply colored jelly.

JELLY OF QUINCES

the parings cores and those Quinces that are not fair answer better
than for any other purpose. boil them three or four hours
untill the water appears glutinous and has a red tinge.
Add a pound of sugar to a pint of the liquid and
simmer it slowly an hour. put it up either in glasses or moulds.

**8 POUNDS QUINCES
(A MIXTURE OF
PEELS, CORES, AND
SMALL OR MISSHAPEN
QUINCES OR ANY
THAT ARE TURNING
BROWN IN PLACES)**

10 CUPS WATER

**2 CUPS SUGAR TO
EVERY 2½ CUPS
STRAINED LIQUID**

**4 ONE-POUND JARS,
WARMED**

Roughly chop the quinces, removing any brown pieces. Put the chopped quinces, together with the peels, into a preserving pan with the water. Bring to the boil and simmer for 3–4 hours, until the water is red-tinged and syrupy. Strain the quinces through a jelly bag. Measure the liquid and return it to a clean pan. Bring the quince liquid to the boil and stir in the sugar until it has dissolved. Boil until the setting point is reached. Skim the jelly and pour it into the warm jars. Cover with waxed greaseproof paper. Cover completely when cold.

❧

A delicate pink jelly with a pungent flavor. Serve it with bread, toasted buns, or muffins or with pork.

QUINCE MARMALADE

scald your quince and pass them through a cullendar.
to every Pint of Pulp add ¾ of a pint of white sugar.
boil it slowly from two to three hours. put your marmalade in a Broad
mouthed jar and you can cut it out in thick slices. when boiling,
carefully stir it from the bottom, as it catches very easily.

8 POUNDS QUINCES	**1½ CUPS SUGAR TO EVERY 2½ CUPS PULP**	**10 ONE-POUND JARS, WARMED**
10 CUPS WATER		

Roughly chop the quinces without peeling or coring them. Put the water into a preserving pan and bring it to the boil. Put in the chopped quinces and simmer them until they are soft and pulpy. Rub the quinces and the liquid through a sieve. Measure the pulp and return it to the rinsed-out pan. Bring the quince pulp to the boil and stir in the sugar until it has dissolved. Simmer, stirring frequently, for 2–3 hours, until the setting point is reached. Skim if necessary. Put the marmalade into the warm jars and cover it with rounds of waxed greaseproof paper. Cover completely when cold.

❧

A stiff, thick jelly that, if put into straight-sided jars, can be eased out and cut into thick slices. It can be eaten with bread, tea cakes, or toasted muffins.

QUINCES PRESERVED

scald your quinces the same way, either whole or in parts.
make your syrup pound to pound wet it with part of the water you
scald them in. add your quinces to the syrup.
let them stand 24 hours, then pour the syrup from them
and boil it ten minutes turn it to the quinces nearly cold.
done in this manner it will never ferment.

| 4 POUNDS QUINCES (ABOUT 25 LARGE, SOUND ONES) | BOILING WATER TO COVER | 8 CUPS SUGAR |
| | | 2 ONE-POUND JARS, WARMED |

Peel, quarter, and core the quinces and drop them immediately into cold water to stop discoloration. Drain them, put them in a bowl, and pour boiling water over them. Leave them for 10 minutes. Strain off the water into another bowl. Put the sugar into a saucepan with 4 cups of the water used for scalding. Set the pan on low heat and stir until the sugar has dissolved. Boil the syrup for 10 minutes, then take the pan from the heat. Put in the quinces and leave them for 24 hours. Lift out the quinces with a perforated spoon and put them into the preserving jars. Bring the syrup to the boil and boil for 10 minutes. Cool and pour it over the quinces. Cover the jars tightly.

Bright pinkish-yellow quinces in a thick syrup. They are very sweet and fragrant and are best served sparingly with ice cream or as a decoration for fancy cakes.

PEACH MARMALADE

*take yellow peaches. peel and slip them put them in your preserving
pan and let them boil fifteen minutes slowly.
add ¾ lb of sugar to each pound of Fruit and boil it slowly 2 hours*

**8 POUNDS MEDIUM
PEACHES** **12 CUPS SUGAR** **8 ONE-POUND JARS,
WARMED**

Scald and skin the peaches. Stone them, slice them, and
put them into a preserving pan. Set them on moderate
heat, bring to the boil, and simmer for 15 minutes. Stir the
sugar into the peaches until it dissolves. Simmer for 2 hours,
until the setting point is reached. Spoon the marmalade into
the warm jars. Cover with waxed greaseproof paper rounds.
Cover completely when cool.

An orange-yellow preserve with a sweet, fruity flavor.

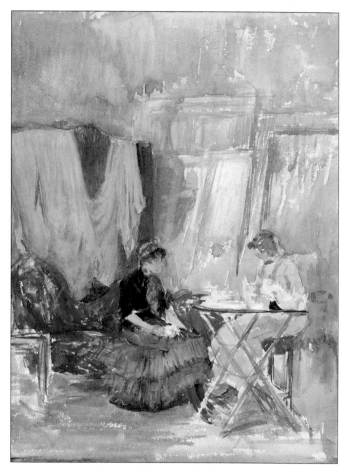

Note in Pink and Purple: The Studio
Painting, watercolor on paper, 30.4 x 22.8 cm (12 x 9 in.)
Freer Gallery of Art, Smithsonian Institution

138 **WHISTLER'S MOTHER'S COOK BOOK**

PICKLES

· · · · · · · · · · · · ·

WALNUTS

*Wash them and scald them, rub off the outer skin, let them lie untill
they are quite cold, then throw them into cold salt and water.
let them lay 24 hours. repeat this for ten days then dry them and lay
them in a glazed vessell, layer upon layer interspersed with spices,
whole mustard seed horseradish sliced shallots a few cloves of
garlick then fill the pot with boiling vinegar stop it close
let it stand 24 hours then pour the vinegar off and boil it again and
pour it upon them as before.*

**5 POUNDS GREEN
WALNUTS (PICKED
WHEN YOU CAN STICK
A PIN THROUGH THE
OUTER SKIN AND
SHELL)**

**4½ CUPS COOKING
SALT**

70 CUPS WATER

**1 TABLESPOON
MUSTARD SEED**

**2 TABLESPOONS
GRATED
HORSERADISH**

6 SHALLOTS, SLICED

**2 WHOLE CLOVES
GARLIC PER JAR,
PEELED**

8 CUPS MALT VINEGAR

**5 ONE-POUND JARS,
WARMED**

Wash the walnuts and put them in a large bowl. Pour
boiling water over them. Dissolve ½ cup of the salt in

7 cups of the cold water. When the walnuts are cool and have turned a dull green, scrape off the thin outer skins, leaving them immersed until you are ready to skin them. As soon as they are skinned, drop them into the brine. Leave them for 24 hours. Strain off the brine and scald the walnuts with boiling water. Put them into freshly made brine and leave them for another 24 hours. Do this every day for 7 more days. On the tenth day, pour off all the brine and rinse the walnuts with cold water. Layer them in jars with the mustard seed, horseradish, and shallots and 2 cloves of garlic per jar. Bring the vinegar to the boil in an enamel or stainless steel pan. Cool it a little so that it will not crack the jars, and pour it over the walnuts. Leave the jars uncovered for 24 hours. Pour off the vinegar and bring it to the boil. Cool it a little and pour it carefully over the walnuts. Cover the jars tightly while they are warm and leave them for two weeks before opening.

❧

Soft, spicy walnuts in a well-flavored vinegar.

RED CABBAGE

slice it thin with a sharp knife
lay it in salt 24 hours then drain it. pack it in a stone jar
pour over it boiling vinegar with some whole spices.

1 RED CABBAGE, APPROXIMATELY 3 POUNDS	1 TABLESPOON WHOLE BLACK PEPPERCORNS	1 DESSERTSPOONFUL BLADE MACE
6 TABLESPOONS SALT	1 TABLESPOON SLICED ROOT GINGER	1 DESSERTSPOONFUL ALLSPICE BERRIES
7 CUPS MALT VINEGAR	1 DESSERTSPOONFUL WHOLE CLOVES	8 ONE-POUND JARS, WARMED

uarter the cabbage and cut away all the tough stalk. Finely shred the rest and layer it in a bowl with the salt. Leave it for 24 hours. Drain it in a colander and rinse it quickly with cold water. Pack it into screw-topped jars. Put the vinegar into an enamel or stainless steel saucepan with the spices. Bring it to the boil. Cover and simmer for 10 minutes. Take the pan from the heat and pour the vinegar over the cabbage, allowing equal portions of spices to go into each jar. Cool and cover tightly. Leave the cabbage for one week before eating, but do not keep it for much longer than three months or it will lose its crispness.

A very subtle and spicy pickle, owing to the fact that the whole spices are poured into the jar with the vinegar and not first boiled with it in muslin and then removed, which is more the practice today.

PICKLED SQUASH

Take the squash pepper cut a slit halfway round the pepper put them in week salt and water. keep them moderately warm by the fire nine days. change the water once. when entirely green put them in hot vinegar and water twenty four hours then put them in good vinegar with a small amount of alum.

4 POUNDS VERY SMALL SCALLOP SQUASHES	22 CUPS COLD WATER	4 TEASPOONS ALUM, APPROXIMATELY
2 CUPS SALT	5 CUPS MALT VINEGAR	2 TWO-POUND JARS
	5 CUPS WHITE WINE VINEGAR	

make a crossways slit halfway into each squash. Dissolve 1 cup of the salt in 10 cups of the cold water. Put the squashes into a large bowl. Pour the brine over them and leave them for four days. Drain the squashes and put them into fresh brine made to the same proportions. Leave them for five days. Drain them and return them to a clean bowl. Heat the malt vinegar with 2 cups of the water and pour over the squashes. Leave it for 24 hours. Drain the squashes and pack them into the jars. Cover them with white vinegar and put 1 teaspoonful alum into each jar.

≈

A good way of preserving the summer's produce for winter. The pickles go well with cold meats.

Note: Although Mrs. Whistler suggests letting the squashes stand in a warm place, this is not really to be recommended, since some of the squashes might mold.

CUCUMBERS

Lay them in salt and water nine days scald them every two days. then put vinegar and water to draw out the salt. let them stand twenty four hour, and put good wine vinegar and a little allum in a stone jar.

4 POUNDS SMALL CUCUMBERS	5 CUPS MALT VINEGAR	4 TEASPOONS ALUM, APPROXIMATELY
3¾ CUPS SALT	5 CUPS WHITE WINE VINEGAR	2 ONE-POUND JARS, WARMED
42 CUPS COLD WATER		

Leave the cucumbers whole. Dissolve ¾ cup of the salt in 10 cups of the water. Put the cucumbers into the brine and leave them for two days. Drain the cucumbers in a colander and pour boiling water over them. Put them into fresh brine made to the same proportion. Leave them for another two days. Repeat the process twice more and then leave the cucumbers for one day. Mix the malt vinegar with 2 cups water. Drain the cucumbers and put them into the vinegar and water for 24 hours. Strain off this liquor. Pack the cucumbers upright into jars and cover them with white wine vinegar. Put 1 teaspoonful of the alum into each jar and cover the jars tightly. Leave the cucumbers for two weeks before opening the jars. Once opened, they should be eaten within two months.

~

A crunchy cucumber pickle that is good with cheese and cold meats.

PRESERVED CUCUMBERS

*green them in salt and water the same as for pickling. then freshen
them by pouring warm water until all the salt is extracted.
those cucumbers that are not very small slit them lengthwise,
and scoop out the seeds, carefully, lay them in a dry cloth,
make a syrup of refined loaf sugar, a pound and a quarter of sugar to
a pound of cucumbers, pour the syrup hot to them, and add the juice
of a lemon, and two ounces of race ginger to every two pounds of
sugar. you must boil the syrup three times a week for two weeks and
pour it to them as hot as possible—*

4 POUNDS SMALL CUCUMBERS	45 CUPS COLD WATER	5 OUNCES BEATEN ROOT GINGER
	10 CUPS SUGAR	
4 CUPS SALT	JUICE OF 2 LEMONS	4 ONE-POUND JARS, WARMED

L eave the cucumbers whole if possible. If they are large, cut them into halves or quarters lengthwise and carefully scoop out the seeds. Dissolve 1 cup of the salt in 10 cups of the water. Pour the solution over the cucumbers, making sure they are all covered. Leave them for two days. Drain the cucumbers and pour boiling water over them. Leave them to cool. Drain them and put them in fresh brine made in the same proportions. Leave them for an additional two days. Repeat the process twice more, then leave the cucumbers for one day. Drain the cucumbers. Put them into a colander and run warm water through them for about 1 minute. Pack them upright into the warm jars. Dissolve the sugar in 5 cups of the water. Add the lemon juice and ginger and bring the pan to the boil. Pour the hot, but not boiling, syrup over the cucumbers. Leave them for two days. Pour off the syrup, boil it up, and pour it back. Leave the cucumbers for another two days and repeat the process five times more. After the last boiling, leave the cucumbers to cool completely, then cover them tightly.

❧

A delicious sweet-cum-sharp preserve with a subtle gingery flavor. It is good with cold meats, particularly poultry and pork.

PICKLED OYSTERS

Drain them from the liquor as much as you think necessary,
half as much vinegar, Cloves, & nutmeg. then just scald them your
Oysters and press them between two plates with a flat iron to keep
them down, then put them into pickle—

48 OYSTERS

½ **CUP VINEGAR,**
 APPROXIMATELY

2 TEASPOONS WHOLE
 CLOVES

2 CHIPS NUTMEG

1 ONE-POUND JAR

Put a sieve over a bowl. Remove the oysters from their shells and empty them and their juice into the sieve. Reserve the juice. Put the oysters into another bowl and pour boiling water over them. Empty them into a sieve or colander to drain away the water. Press down hard on the oysters to extract as much juice as possible. Put them into a jar. Measure the juice and add half as much distilled malt vinegar. Put the juice and vinegar into a saucepan with the spices and bring them to the boil. Cool a little and strain the liquid over the oysters. Put them in the jar and cover with a tight-fitting lid, if they are to be stored, or put them in a bowl if they are to be eaten soon. Cool the oysters. They will be ready to eat after 24 hours and should not be kept longer than a month. Eat them all as soon as the jar is opened.

≈

A pickle that preserves all the natural flavor of the oysters. It can be served on cocktail sticks as an appetizer or as a first course for 6 people.

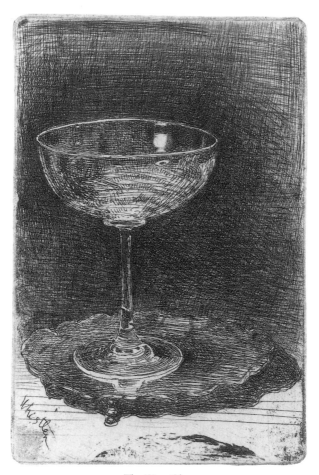

The Wine Glass
Etching, first state, 8.2 x 5.7 cm (3¼ x 2¼ in.)
Freer Gallery of Art, Smithsonian Institution

CORDIAL

· · · · · · · · · · · ·

PEACH CORDIAL

300 Peach pits. 3 quarts Brandy, 1 quart water,
Do of rose water, 2 lb loaf sugar.

300 PEACH STONES	5 CUPS BOILING WATER	5 CUPS ROSE-WATER
4 CUPS SUGAR	15 CUPS BRANDY	BOTTLES AS REQUIRED

Crack the peach stones and chop the kernels. Put them into a heat-resistant plastic container or earthenware vessel with the sugar. Pour on the boiling water and leave the mixture to cool. Cover and leave for 4 days, stirring every day. Strain, add the brandy and rose-water, and bottle the mixture. Leave for 1 month before opening.

≈

A sweet, strong cordial to be drunk in liqueur glasses. It has a hint of bitter almonds and the perfumed aroma of rose-water.

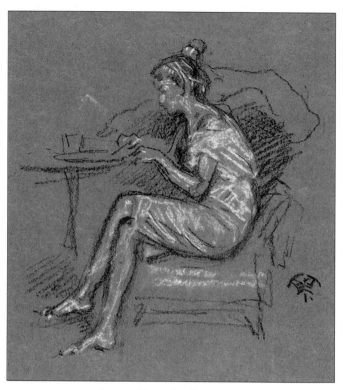

Japanese Figure, Seated, c. 1870–1875
Drawing, black and white chalk on paper, 28.2 x 18.0 cm (11⅛ x 7⅛ in.)
Freer Gallery of Art, Smithsonian Institution

INDEX

· · · · · · · · · · ·